150 YEARS OF
CLIFTON SUSPENSION BRIDGE
A PHOTOGRAPHIC HISTORY

150 YEARS OF
CLIFTON SUSPENSION BRIDGE
A PHOTOGRAPHIC HISTORY

MICHAEL PASCOE

The
History
Press

Cover illustrations: Front: Clifton Suspension Bridge today (Zed-com Photography); Rear: The only surviving photograph of the opening ceremony of the bridge. (Clifton Suspension Bridge Trust)

First published 2014

The History Press
The Mill, Brimscombe Port
Stroud, Gloucestershire, GL5 2QG
www.thehistorypress.co.uk

British Library Cataloguing in Publication Data.
A catalogue record for this book is available from the British Library.

ISBN 978 0 7509 5461 7

Typesetting and origination by The History Press
Printed in India by Nutech Print Services

CONTENTS

ACKNOWLEDGEMENTS

The author is most grateful for the help and support of:

Dave Anderson
Adrian Andrews
Simon Bishop
Dawn Dyer
Francis Greenacre
Jenny Gaschke
Laura Hilton
Helen Jeffrey
Mandy Leivers
Hannah Lowery
Tom Mowcek
Mark Neathey
Rachel Profit
Michael Richardson
Derek Smith
Ray Smith
Sue Stops
Laura Valentine

Additional photography by www.robscottphotography.com

INTRODUCTION

In a BBC poll of 2003, viewers voted Isambard Kingdom Brunel the second greatest Briton after Sir Winston Churchill. The Olympic torch was carried across the Clifton Suspension Bridge, and Brunel was depicted in the 2012 London Olympics opening ceremony, played by the actor Sir Kenneth Branagh.

Among Brunel's many engineering achievements, ranging from railways to ships, bridges to docks, his design for Bristol's Clifton Suspension Bridge, which he called in his diary 'my first child, my darling', had a special place in his affections as the project that launched his spectacular career. He also had a fondness for the city and once wrote of his 'strong wish of being a Bristol man'. The bridge is not his only surviving Bristol project – his SS *Great Britain* and his work on the docks survive in the city, as do much of his Temple Meads Station and the facade of his Great Western Hotel.

Brunel's affection for his bridge is shared by Bristolians, and it has become as much the symbol of the city as the Eiffel Tower of Paris or the Opera House of Sydney. Numerous local firms, societies and clubs have adopted the bridge as a logo or use the name 'Brunel'.

While other suspension bridges of the period have been demolished, replaced or significantly altered, the Clifton Suspension Bridge remains – a symbol of Britain's burgeoning Industrial Revolution. It is still an international visitor attraction, and is conscientiously maintained by the Trustees, successive bridgemasters and their staff, relying solely on income from the tolls.

With the approach of the 150th anniversary of the bridge in December 2014, this book tells its story in both words and pictures.

Bristol's pride in the bridge is reflected in the large number of local firms, societies and clubs that use the bridge as their logo and those who use 'Brunel' in their titles. They range from bars to beauty parlours and from tailors to taxis. (Clifton Suspension Bridge Trust)

CLIFTON PARKE

Proprietor: Albert York

2 & 3 Waring House
Redcliffe Hill
Bristol BS1 6TB
Tel: 0117 921 1692

Bristol Golf Centre

Brunels

REMOVAL SERVICES

BRUNEL
TRAINING GROUP
B·T·G

Brunel
Scaffolding Ltd.

Bristol Area Kidney Patients Association
Working For Patients

HM PRISON
BRISTOL

SERVICE WITH CARE

BRUNEL
PRESERVATIONS LTD

HOTWELLS
primary school

CLIFTON WINDOW CLEANERS

Bridge Stores

BRUNEL
PATTERN MAKING COMPANY

CLEANING
J.W.CREESE & SONS LTD

Bristols PREMIER WINDOW, CARPET & CLEANING CONTRACTOR
Telephone 0117 969 2471 Mobile 07976 580 464

Brunel Raj

INDIAN CUISINE

1

'A GREAT PUBLICK UTILITY'

On 1 December 1753 an ailing Bristol wine merchant, William Vick, made his will. A very wealthy man, he made bequests of more than £1,500 each to his unmarried sister, his business partner, his friends and servants. He also made several substantial donations to Minchinhampton church in Gloucestershire, his native parish, as well as £50 to the Bristol Infirmary. In addition, his 'friend and partner' was to receive a further 30 guineas 'to be applied for such secret purposes as I shall direct him, without accounting for the same to any person whatsoever'.

Vick's major legacy, however, was the stipulation that on their deaths his sister should leave £666 13s 4d and his business partner £333 6s 8d to the powerful merchants' guild, the Society of Merchant Venturers. This sum, totalling £1,000, was to be invested and used for a specific purpose, which his will made extremely explicit:

> I am of the opinion that the Erecting of a Stone Bridge over the River Avon from Clifton Down in the County of Gloucester to the opposite side on Leigh Down in the County of Somerset for Carriages as well as Horse and Foot Passengers Toll Free would be a great publick utility and I have heard and believe that the Building of such a Bridge is practicable and might be completed for less than ten thousand pounds.

The merchants were directed to invest the sum until it reached the value of £10,000, which he believed would cover the cost of obtaining the necessary Act of Parliament and compensate the owners of the Rownham Ferry that served as the main means of crossing the River Avon. The 'secret purpose' with which this bachelor had charged his partner, and the hospital for illegitimate children he suggested founding if the bridge could not be built, caused 'as much amusement as surprise' in the city. Vick was not a Merchant Venturer, but no doubt considered the

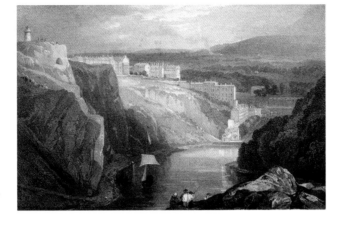

Described as 'a wonderful passage through a mighty hill' by Jacob Millard in 1673, the sheer St Vincent's Rocks rise to 300ft on the Clifton side. (Private Collection)

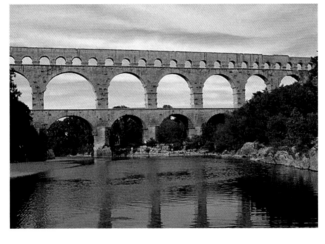

Built by the Romans in around 19BC, the Pont du Gard is both aqueduct and viaduct and has survived for over 2,000 years largely intact. Stone or timber construction remained the only methods of bridge building until the use of iron began in the late eighteenth century. (Private Collection)

In an age before refrigeration and plastics, coopers made a range of wine, beer and spirit casks to hold various amounts of liquids. Their products were essential for domestic and maritime storage and for jugs, butter churns, buckets etc. (Carningli Press)

entrepreneurial society, which dated back to 1551, more trustworthy than the corrupt Bristol Corporation or the first private provincial bank outside London, which had been established in the city only four years previously.

Vick's scheme remains something of a mystery. At the time of his death the population of Clifton on the hill was a mere 300, and its grand terraces were many years in the future. On the Somerset side were large, privately owned country estates and sparsely populated countryside.

The site he chose was the narrowest point, but also the highest. Nearer the city or downstream, building a bridge that would meet the Admiralty's requirements of 100ft clearance, for their tall-masted warships to be able to pass underneath, would have meant massive and expensive viaducts to raise the roadway. But even with the growth of Clifton in the nineteenth century, the bridge remained financially unviable for many years.

There was also the question of the method of construction. No stone bridge of over 200ft

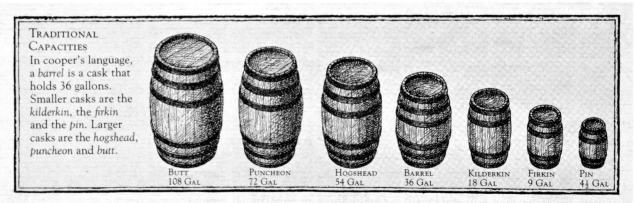

TRADITIONAL CAPACITIES
In cooper's language, a *barrel* is a cask that holds 36 gallons. Smaller casks are the *kilderkin*, the *firkin* and the *pin*. Larger casks are the *hogshead*, *puncheon* and *butt*.

BUTT	PUNCHEON	HOGSHEAD	BARREL	KILDERKIN	FIRKIN	PIN
108 GAL	72 GAL	54 GAL	36 GAL	18 GAL	9 GAL	4½ GAL

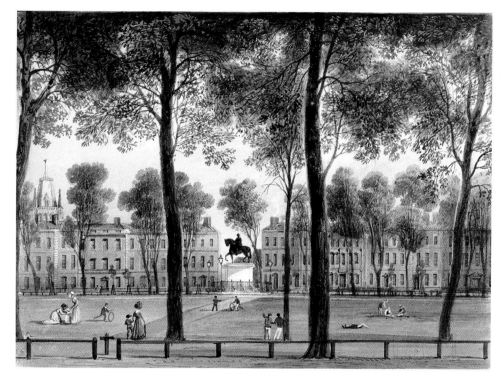

Clockwise from left: Minchinhampton was a well-to-do centre of the Cotswold wool trade, with a population of about 1,800 at the time of Vick's birth. His baptism is recorded in the parish records. (Gloucestershire Archives); Most of Bristol's population still lived in the crowded and polluted medieval city. This huge square was the first development to be built outside the city walls and was named in honour of Queen Anne after her 1701 visit. In the centre stands a statue of William III. (Bristol Museums, Galleries and Archives); William Vick was buried in Holy Trinity Church in Minchinhampton. His grave was moved during restoration work in 1842. He is marked now only by a brass plaque, one of many in the graveyard. (Private Collection)

span had been attempted before, yet at this point the gorge was 800ft across. The cost of materials and labour would have been far in excess of the £10,000 he had been advised. The only alternative would have been a viaduct, as at the Pont du Gard in France, potentially blocking passage in the river.

In 1724 Vick had become apprenticed as a 'hooper', or cooper, in Bristol. By 1732 he had completed his apprenticeship and was now a feeman of the city, entitled to set himself up in business on his own account and to vote (but he never became an alderman, as is sometimes claimed). He joined forces with a local publican and began importing wine – so successfully that he was soon able to move into the recently completed upmarket Queen Square, later to play a crucial role in the story of the bridge.

Life was not all work and no play. Vick, his sister and his business partner were all enthralled by the theatre. While still an apprentice, Vick subscribed £300 towards the opening Bristol's first playhouse in Jacob's Wells, just outside the city boundary in Gloucestershire and therefore out of the jurisdiction of the puritanical Bristol magistrates.

Just weeks after making his will, Vick died, aged just 47, on 3 January 1754 and was buried in Minchinhampton.

2

'THE DIRTIEST GREAT SHOP'

'Brycgstow', meaning 'the place of the bridge', is first mentioned in the *Anglo-Saxon Chronicle* of 1051. This original bridge's site, now in the centre of the city, was one of the few where the River Avon could be forded – marshes, muddy banks or high cliffs made crossings elsewhere extremely difficult, and often impossible for horse-drawn vehicles. The four-arched bridge had at least thirty-five five-storey houses lining its sides and became the major crossing point for a north–south road axis linking Gloucester and the Midlands with the South and South West.

The city in which Vick lived and worked was bustling and prosperous. River and international sea trade, shipbuilding and industries such as metalwork, sugar refining, soap making, glass manufacture and the infamous slave trade all combined to make Bristol the second largest city in England and the capital of the South West.

A guide book of the 1720s claimed that Bristolians:

… give themselves up to trade so entirely that nothing of the politeness and gaiety of Bath is to be seen here; all are in a hurry, running up and down with cloudy looks and busy faces, loading, carrying and unloading goods and merchandises of all sorts from place to place; for the trade of many nations is drawn hither.

Horace Walpole was uncomplimentary, reporting that 'the Bristolians seem to live only to get and save money … the dirtiest great shop I have ever seen'.

Tourism also flourished. In 1686 the Society of Merchant Venturers had become Lords of the Manor of Clifton. By building a pump room above a reputed healing spring at the city end of the Avon Gorge, below the site of the present bridge, they promoted a popular spa. Although

Opposite: Bristol Bridge was built in 1247 and, like several others of the same era around the country, was showing its age by the eighteenth century. Despite this, its shops had the highest rates in the city. With ninety-six carriers distributing goods to over a hundred destinations it is not surprising that traffic jams and accidents were common at this pinch point. (Bristol City Reference Library)

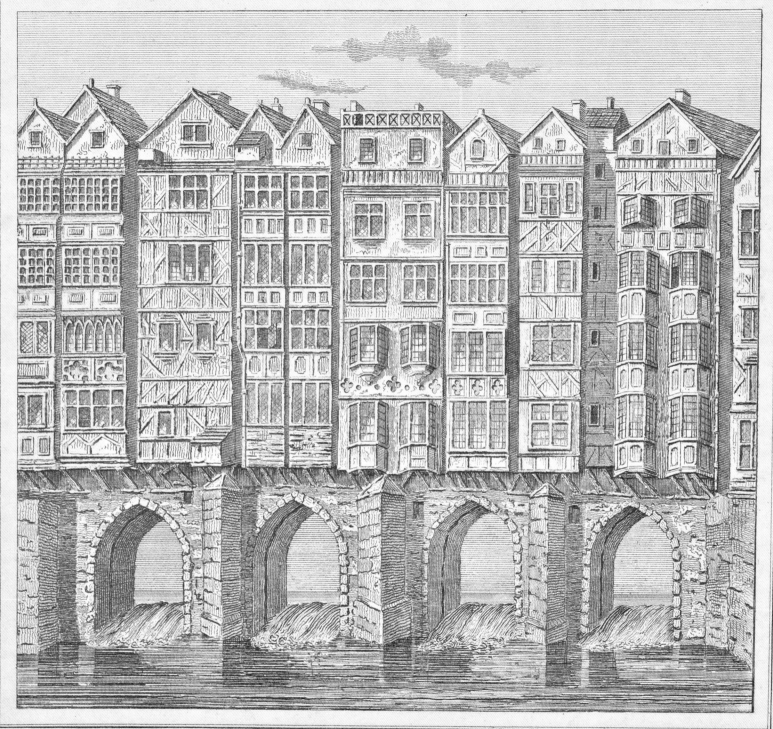

M.A.S. delin.

THE OLD BRISTOL BRIDGE.

This arch with St John's Church above is the last of Bristol city's entrances to survive. Through the gate entered Queen Elizabeth I on a state visit in 1574. It was not until the second half of the eighteenth century that the narrow entrance gates began to be removed. (Private Collection)

the Bristol Hotwell never quite rivalled 'the gaiety of Bath', it attracted not only significant numbers of invalids, but also those in search of pleasure, who, after spending the winter in Bath, moved to Bristol in the spring and summer to dance in the two assembly rooms.

During the later eighteenth century Bristol entered a long and slow period of decline that lasted well into the following century. Other ports, especially Liverpool with its cheaper dues and more accessible docks, overtook Bristol, and the rise of the northern industrial towns meant that Bristol was no longer the country's second most important city. Commissioners visiting the city in 1833 in connection with local government reform remarked that Bristol was 'far below her former station as the second port of the empire. She now has to sustain a mortifying competition with second-rate ports in her own Channel.' Despite occasional short-lived booms, the decline was steady, making the task of finding funds for building the bridge a difficult one.

In 1732, Alexander Pope said of Broad Quay: 'as far as you can see, [were] hundreds of ships, their masts as thick as they can stand by one another … [it was] fuller of them than the Thames from London Bridge to Deptford.' This picture of Broad Quay, taken around 1870, shows goods moved on sledges to avoid disturbing the wine in the cellars below the streets. (Bristol Museums, Galleries and Archives)

3

'BRISTOL'S GREAT INCONVENIENCES'

In 1723, Daniel Defoe, in his book *A Tour Thro' the Whole Island of Great Britain*, wrote: 'The greatest inconveniences of Bristol are its situation, its narrow streets and the narrowness of its river.' William Vick would have been well aware of Bristol's deficiencies. The refuse-strewn medieval narrow streets – 'as narrow as the minds of Bristolians', claimed a travel guide – with overhanging houses and trade signs, made for difficulties for high loads. The city gates, in particular, impeded traffic, yet incredibly the council still spent money on them, until they were eventually demolished in the second half of the century. The only surviving gate, St John's, gives an idea of the problem.

Five small ferries traversed the River Avon at various points in Bristol, but to cross with substantial loads, large vehicles or carriages it was necessary to add to the traffic congestion by crossing the bridge. After paying a toll, travellers crossed the bridge on a roadway that was a mere 14ft wide and had a steep rut in the centre, causing vehicles to collide with one another and lead to bottlenecks. Pedestrians risked being crushed, and accidents were common. Once across the bridge, the road forked to Bath on the left whilst on the right, leading out of the city on the Somerset side, there was little but a cart track, suitable only for packhorses and almost impossible for heavy wagons or carriages to use. The only alternative route, avoiding Bristol Bridge, was to travel 6 miles upstream to a medieval packhorse bridge at Keynsham. Vick possibly saw a new bridge as a bypass.

The other 'greatest inconvenience' mentioned by Defoe was access to the harbour, 6 miles upstream from the Bristol Channel. Vessels could sail up- and downriver only on the high tide. The mean spring tide at the river mouth, the world's second largest rise and fall, reaches 40ft. (The Bay of Fundy in Nova Scotia claims the record.) Twice in every twenty-four hours, millions of gallons of water sweep up the river, making for perilous navigation. For vessels proceeding

Generation after generation of 'hobblers' and pilots lived on the banks of the River Avon in the Somerset village of Pill and towed vessels up the twisting river. (Society of Merchant Venturers)

upriver in Vick's time, the course lay through the winding Avon Gorge, with its fickle winds and 1½ miles of tortuous bends. Larger ships needed to be towed by 'hobblers' – usually several generations of a family, who worked in teams of as many as ten strong oarsmen in rowing boats to keep the ships' heads steady. Failure to make the passage on one tide ran the risk of running aground. Even steam-powered ships, in the nineteenth century, occasionally ran into difficulties, blocking the river for days on end.

Once arrived at the docks, there was the problem of finding a mooring and, if possible, unloading the ship before the tide ebbed and the vessel sank below the quay on to the mud banks. It is claimed that

the phrase 'shipshape and Bristol fashion' was coined to describe those vessels built strong enough to withstand the strain of settling without leaning over and breaking their backs. Once in harbour, which also acted as the city's main sewer, ships could only leave when the tide was high and the wind in the right direction.

For those not forced to sail, the gorge was and remains fascinating. On the heights above St Vincent's Rocks on the Clifton side are earthworks, the remains of an Iron Age camp dating from about 300 BC. This faced two other camps across the river and must have presented a formidable obstacle to potential invaders.

At the very summit of the cliff on the Clifton side stands a former mill, converted into an observatory with a telescope and a camera obscura in the 1830s by the artist William West. (A camera obscura is a kind of periscope that projects a 360-degree image of the surrounding area on to a white dish below.) He also built a 90ft-long tunnel leading down to what is called the 'Giant's Cave' in the face of the gorge.

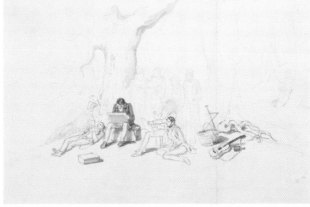

The striking natural beauty of the Avon Gorge has acted as a magnet for artists for over three centuries: the Bristol School of artists flourished in the 1820s and '30s.

The Bristol School of Artists, seen here in a sketching party in Leigh Woods, have left a unique collection of portraits of the city in the early nineteenth century, just before the advent of photography. Many views were commissioned by George Weare Brakendridge, a wealthy local merchant. (Bristol Museums, Galleries and Archives)

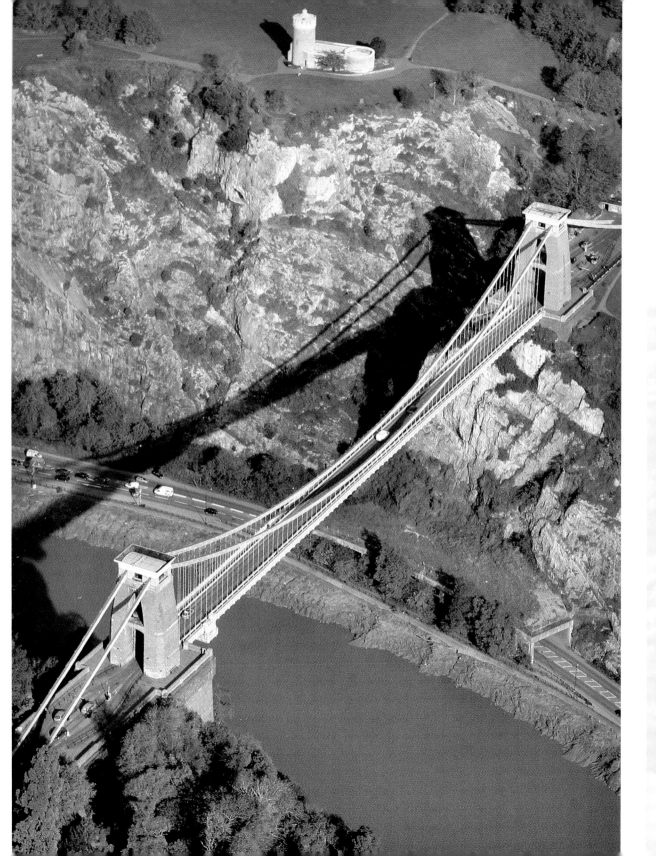

William West's camera obscura in the Observatory is still functioning, one of only two left. The cave in the cliff face of St Vincent's Rocks is said to have been the home of a medieval hermit and is also known as the Giant's Cave. On the other side of the gorge are the 440 acres of Leigh Woods. (Destination Bristol)

4

'A RAGE FOR BUILDING'

At the time of Vick's death in 1754 the rural hamlet of Clifton on the hill consisted mainly of grazing land and some market gardens, while most development was along the riverbank. The Clifton countryside was a place for excursions and picnics for visitors taking the waters at the Hotwells Spa. Thirty years after Vick's death a national building boom followed the end of the American War of Independence. From about 1783 a decade of large-scale land development began. By 1791, Sarah Farley's *Bristol Journal* reported that: '... we hear ground is actually taken for three thousand houses', and other reports mention a 'rage for building' and a 'building frenzy'. In Clifton, at least fifteen major terraces were begun during this period.

On 26 January 1793, Felix Farley's *Bristol Journal* announced: 'An artist has presented a plan for a bridge from Clifton to Leigh Down which, if put into execution, promises to be of great utility.' The proposal was by William Bridges, who described himself as an artist and inventor but of whom little else is known. Shiercliff's *Bristol and Hotwell Guide* of that year said: ' ... if ever put into execution and perfected, [it] will be the noblest one arch bridge in the world'.

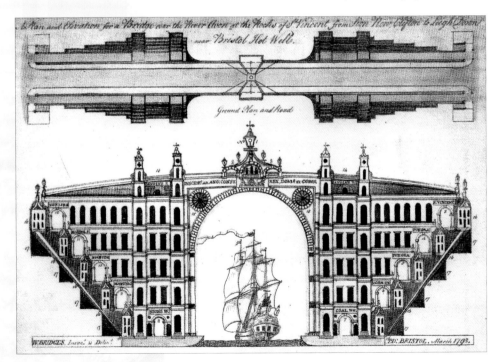

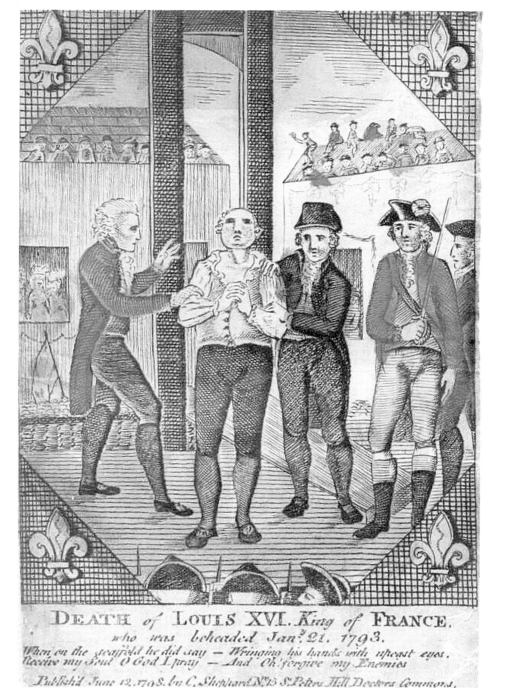

DEATH of **LOUIS XVI.** King of **FRANCE.**

who was beheaded Jan.y 21. 1793.

When, on the scaffold he did say — Wringing his hands with upcast eyes.
Receive my Soul O God I pray — And Oh forgive my Enemies

Publish'd June 12. 1798. by C. Sheppard N.º 15 St Peters Hill Doctors Commons.

Left: The guillotining of King Louis XVI in 1793 caused dismay and consternation throughout establishment Europe and led to a war with France which lasted almost twenty years, culminating in the Battle of Waterloo in 1815. (Private Collection)

Opposite: William Bridges' massive structure was 200ft high and 700ft overall, with each storey 40ft high. It included a lighthouse for which every passing ship would pay a toll, a toll house for collecting the fees, an observatory, chapel, granaries and corn exchange, a coal wharf, and a wharf for selling stone, lime and ballast. In addition it contained 'Manufactories, for the Employment of the industrious Poor', a nautical training school, public museum, library and subscription rooms, plus twenty dwellings and stables. Engine rooms and two windmills in the spandrels of the arch could raise water, grind corn, and lift stone and coal. The inscription in abbreviated Latin, Inscrip:Ang:Const.Rex.Doms Et Coms, translates as 'To the Constitution of England, King, Lords and Commons', but is claimed by some classicists as not being grammatically correct! (Private Collection)

Bridges may well have had some doubts about the possibility of constructing a stone bridge across this span. The Guide mentioned that:

> James Lacy Esq, the designer of Ranelagh-house [the Ranelagh pleasure gardens in London] was consulted on the project of building a bridge of one arch, from rock to rock, over the river Avon; he thought it practicable, and offered to make a plan and estimate the expense of doing it, which if ever put into execution and perfected, will be the noblest bridge of one arch in the world; and as Durdham Down and Leigh-down would thereby become connected, estates in the vicinity of the latter would be worth double their present value.

The plan for a bridge was dramatic, imaginative and truly monumental. It would fill the gorge, and it had economic potential, but it was old fashioned in design compared to the new bridges being built elsewhere. Despite this, *Felix Farley's Bristol Journal* gave a warm welcome to the proposal.

The timing of this grandiose project could not have been worse. By 1792 the danger signs for builders and developers had begun to appear. Inevitably, supply exceeded demand and too much credit had been extended to speculators. The highly profitable days of the African trade were well past and commerce with the West Indies and the newly independent America was declining, while the ports of Liverpool and Glasgow were also attracting more and more business away from Bristol. In 1807 a traveller visiting Clifton wrote of 'the silent and falling houses … almost all of which are so nearly finished as to represent the deserted streets occasioned by a siege, or the ravages of a plague'.

In the same edition of the *Bristol Journal* in which Bridges' plan was reported, it was also announced that King Louis XVI had been guillotined and 'Monsieur Chauvelin' (actually the Marquis de Chauvelin), the French Ambassador to Britain, had immediately been expelled. The following week's issue brought the news that Britain was at war with Revolutionary France. The resultant collapse in building development in both Bristol and Bath was almost total. Food and other riots, plus an outbreak of the plague, contributed to a melancholy end to the century in Bristol and Bridges' plans sank without trace.

5

'THIS NOBLE APPLICATION OF ART'

When William Vick made his will, major bridge building had changed little from Roman times, with stone and timber the only two materials used. Yet just over twenty years after his death a cast-iron bridge at Coalbrookdale, Shropshire, was constructed. Erected far more speedily than traditional masonry bridges, it cost much less, and similar bridges began to appear elsewhere before the turn of the century. The radical use of iron as a material completely changed the nature of bridge building. However, tests as to its strength by leading engineers such as Thomas Telford and Marc Brunel showed that, although strong when compressed, cast iron was weak in tension and there were therefore limits to the material and what could be achieved with it. The use of cast iron for a single span across the broad width of the Avon Gorge would not have been feasible; the answer to the problem lay in wrought iron. Though this material had long existed, in 1784 Henry Cort had revolutionised the manufacturing process by adding ferric oxide to iron to expel the carbon. This allowed it to be produced far more quickly and cheaply, meaning it was now suitable for use in large-scale projects. Leading engineers, working with iron manufacturers, tested the tensile strength of wrought iron and proved that it was ideal for chains. The age of the suspension bridge was about to arrive.

Judge James Finley takes the credit of being the first designer of the modern suspension bridge. In 1801 he built a bridge with a span of 69ft crossing Jacob's Creek, Pennsylvania, using chain links from hand-forged wrought iron. These bridges could be constructed using local materials and skills, were quicker and easier to build than masonry bridges, and were far cheaper. Finley built over a dozen more bridges, and by the time of his death in 1828 around fifty bridges had been erected to his design, the longest with a span of 306ft.

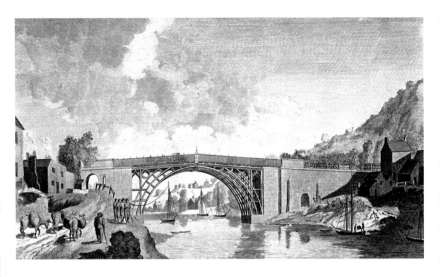

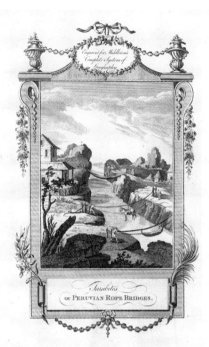

Bottom of page: Modern constructions such as the Humber Bridge share the same engineering principles; it is the technology and materials that have changed. Essentially, a roadway or 'deck' is hung from some supporting cable or chain construction. The cable is then 'anchored'. In primitive bridges this is done by tying vine ropes to a tree. In more advanced constructions metal cables are secured deep into the ground on both sides after being passed over 'saddles' on towers, which take the strain. The roadway is then hung from the chains by means of suspension rods. In the pre-steel early nineteenth century the cables were made of wrought-iron wire or bar chain forged off-site, as at Clifton. On each side of the Clifton bridge is a sway guide, designed to allow the bridge to rise and fall but preventing it moving sideways. By standing with one foot on the path and one on the bridge deck, one can feel the movement of the bridge, which varies according to temperature and load. (Private Collection)

Above: The cast-iron bridge at Coalbrookdale with a 100ft span has become a world-famous symbol of the Industrial Revolution and still stands. It is claimed that other cast-iron bridges were built earlier, one over the River Ure at Boroughbridge and another with a 72ft span at Kirklees Park, both in Yorkshire. (Private Collection)

Right: The principle of the suspended bridge was not a new one. Rope bridges across gorges, such as this one in Peru, have existed for centuries in South America and Asia. (Private Collection)

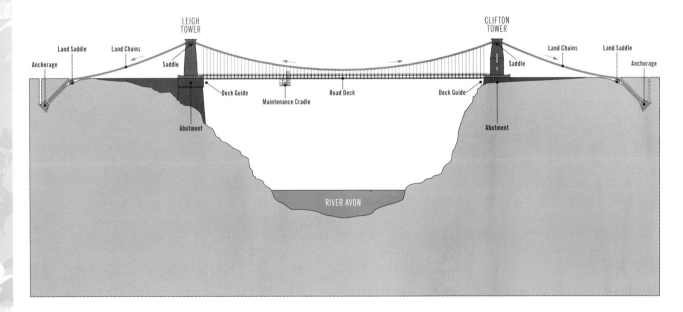

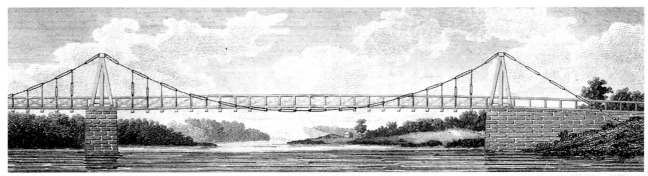

Judge James Finley used wrought iron to construct his bridges in America, several of which later collapsed due to the impact of extreme weather or poor forging of the iron. (Private Collection)

Finley's ideas spread to Britain. The first major suspension bridge to be completed was designed by Captain Samuel Brown RN. Applying the principles of ships' rigging, he developed and later patented eye links and used these to construct the aptly named Union Chain Bridge with a 449ft span across the River Tweed, linking England and Scotland. The construction took less than a year and cost only £7,700. Most of Brown's designs used an unstiffened road deck and it was some time before it became generally apparent that bridges of this type were susceptible to strong winds and unstable when crossed with heavy loads.

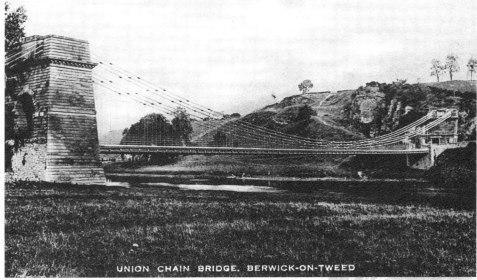

UNION CHAIN BRIDGE. BERWICK-ON-TWEED

The Union Chain Bridge, with a span of 449ft, was the longest suspension bridge in the world when it opened. It is the oldest surviving suspension bridge, allowing vehicles to cross, but has been much strengthened over the years. (Private Collection)

Two years after the construction of the Union Chain Bridge, Marc Brunel, with his 16-year-old son Isambard acting as his assistant, designed two prefabricated suspension bridges, which were made in Sheffield and shipped to the French possession of the Île Bourbon (now Réunion) in the Indian Ocean.

One of the greatest challenges facing the government and engineers in the early nineteenth century was to link mainland Wales with the Isle of Anglesey, the main route for mail and traffic to the deep-water port of Holyhead and thence to Ireland. Thomas Telford amazed the world when he solved the problem by designing and building the mammoth Menai Strait Bridge. Its span of 579ft between the piers was far longer than anything attempted previously. The bridge was approached over viaducts on both sides and the total length was 1,710ft, with towers soaring to 153ft to allow for the Admiralty requirement of 100ft clearance for its ships. In January

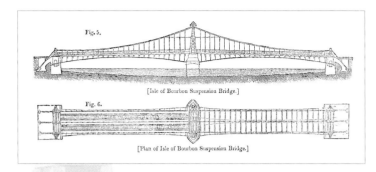

Fig. 5.

[Isle of Bourbon Suspension Bridge.]

Fig. 6.

[Plan of Isle of Bourbon Suspension Bridge.]

Marc Brunel's two bridges for the volcanic Île Bourbon (now Réunion) had a span of 131ft 9in for the shorter and two equal spans of 131ft 9in on either side of a central tower for the longer. Both were strongly braced against hurricanes, which could reach over 100mph. (Private Collection)

1826 the first mail coach made a triumphant crossing and the bridge drew an admiring crowd of 70,000 visitors in its first year alone. Telford's resident engineer boasted that the publication of Telford's design led to the construction of bridges and piers 'in almost every part of the kingdom'. The *Penny Post for the Diffusion of Useful Knowledge* was one of its many admirers, claiming that 'this noble application of art ... only required minds whose genius was fitted to direct the suspensive principle of bridge-building on a scale commensurate to the wants of the time'.

After the first two decades of the new century, recovery from the Napoleonic Wars slowly began. The unfinished terraces at Clifton were completed piecemeal by small builders, and in 1822, in an attempt to revive the flagging spa, the Merchant Venturers built a new Hotwell House in the Tuscan style.

Alderman Thomas Daniel, nicknamed 'The King of Bristol' for his control of the city council, had fingers in many pies. The owner of more slaves than any other Bristol merchant, he was to receive no less than £117,000 after the Abolition of Slavery Act of 1833, in compensation for the freeing of almost 4,000 slaves. Always ahead of the game, as early as 1822 Daniel commissioned an artist and architect, Hugh O'Neill, to produce designs for a suspension bridge. O'Neill's design imitated the Union Chain Bridge, and his drawings identified two potential crossing points,

Hugh O'Neill (1784-1824) was best known as an architectural draughtsman. He came to Bristol in 1821 and made over 500 drawings of the city as well as designing a suspension bridge. (Private Collection)

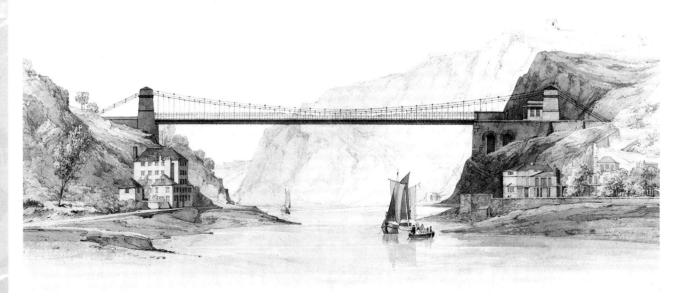

but the plan lapsed. Daniel probably hoped that this development would provide employment during the post-war slump and attract tourists to the newly built Hotwell House.

By 1829, following pressure largely from the recently formed Chamber of Commerce, Bristol began to have aspirations to become a steam-packet port for the lucrative mail contract to Southern Ireland. Steamboats were now coming into increasing use, as they were far less subject to adverse winds and tides than sail-powered vessels. In March the Merchant Venturers resolved to petition the Treasury for the establishment of a steam-packet station at Portishead on the north Somerset coast, 'connected also with the erection of a Bridge across the Avon' – Vick's bequest having now reached £8,000. At the same time they sought legal advice as to whether Vick's will could be changed to allow a 'chain bridge' rather than a stone structure, which it was estimated would cost about £30,000, as opposed to £90,000 for a stone bridge. The shortfall would be financed by subscriptions and toll charges. A committee of Bristol's great, good, and not so good was formed to obtain costings and surveys, with the aim of submitting a Bill to Parliament. The following announcement appeared in newspapers and in journals both locally and further afield (Private Collection):

SUSPENSION BRIDGE

Bristol 1st October, 1829

ANY Persons willing to submit DESIGNS for the ERECTION of an IRON SUSPENSION BRIDGE at CLIFTON DOWN over the River AVON, to the consideration of the Committee appointed to arrange proceedings for carrying the measure into execution, are requested to forward the same, accompanied by an Estimate of the probable expense addressed 'To the Bridge Committee, at the Office of Messrs. OSBORNE and WARD, Bristol', on or before the 19th day of November next.

Should any of the Plans so furnished be adopted, the sum of One Hundred Guineas will be given to the Person furnishing the same, unless he shall be employed as the Engineer in the execution of the Work.

For further Particulars apply to Messrs. OSBORNE and WARD, Bristol.

Notice is hereby given, that Application is intended to be made to Parliament, in the ensuing session, for leave to bring in a Bill to erect a BRIDGE over the River AVON.

6

'A MONUMENT OF ARCHITECTURAL TASTE AND SPLENDOUR'

Despite the short notice given in the advertisement, various writers have claimed that twenty-two plans were submitted. Unfortunately, no definitive list of the entrants remains; however, fourteen names of engineers, architects and ironmasters have been given by various sources. Amongst those cited are William Hazeldine from Shrewsbury, Shropshire, Telford's preferred iron manufacturer; and William Hawkes of Smith and Hawkes of the Eagle Foundry, Birmingham; Bristol-born William Tierney Clark, builder of the the first suspension bridge across the River Thames at Hammersmith two years before, submitted a plan which has not survived. The designs of Devonian James Rendel and Brunel do still exist. Fifteen year-old William Butterfield was not invited to submit his design, and neither was William Young, a Bristol mason.

Fairly recently, Brunel family papers revealed that Marc wrote to his son in October 1829 enclosing a sketch of his idea for a bridge. Marc felt that the gorge could not be crossed in one span. His plan was for a Chines-style pagoda tower, 300ft high, from which two suspension bridges crossed the river and were anchored in the rocks. His son totally rejected the idea.

Before producing his designs, 23-year-old Brunel spent two days thoroughly inspecting Telford's Menai Bridge, which was frequently being damaged by gale-force winds, and concluded that the deck was 'far too light'. He submitted beautifully drawn plans for four bridges, with spans ranging from 720ft to 1,160ft. Unlike some of his rivals, he appreciated the splendour of the gorge and, in a supporting document to his designs, stated that he had wished to design a bridge 'the grandeur of which would have been consistent with the situation'. True to his word, his range of striking plans included a particularly daring version that involved a tunnel through the Giant's Cave in the face of the gorge and a span of 980ft leading to another tunnel on

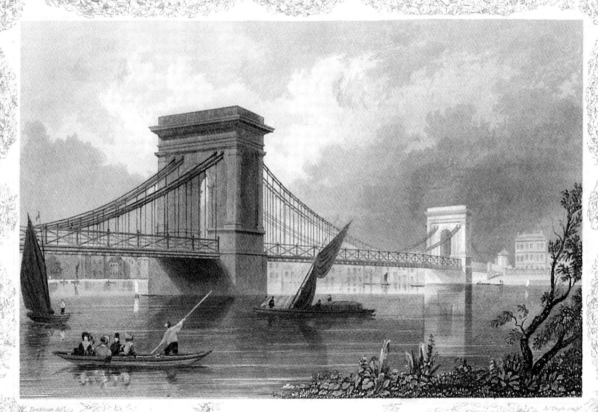

HAMMERSMITH BRIDGE.

London, Published by Tombleson & Co. 11 Paternoster Row
Germany, Carobehaus & Co. Collection

HAMMERSMITH BRÜCKE

PONT D'HAMMERSMITH

William Butterfield (1814–1900) was a 15-year-old London builder's apprentice when he submitted his flamboyant design. He went on to become a celebrated church architect. (Clifton Suspension Bridge Trust)

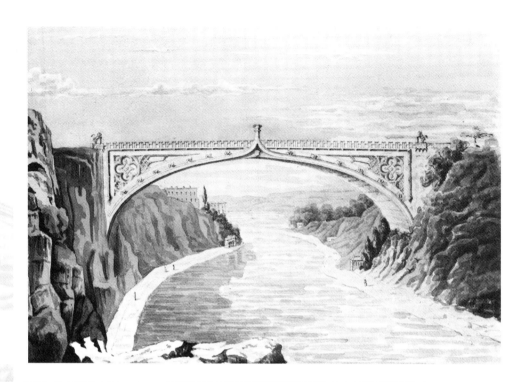

James Rendel (1799–1856) was also a former Telford pupil. Rendel built the second-longest cast-iron bridge across the River Plym in Devon in 1827. He later designed harbours in Britain and overseas, and was a pioneer of steam-powered chain ferries. His design for Clifton was costed at a massive £92,885. (Bristol City Reference Library)

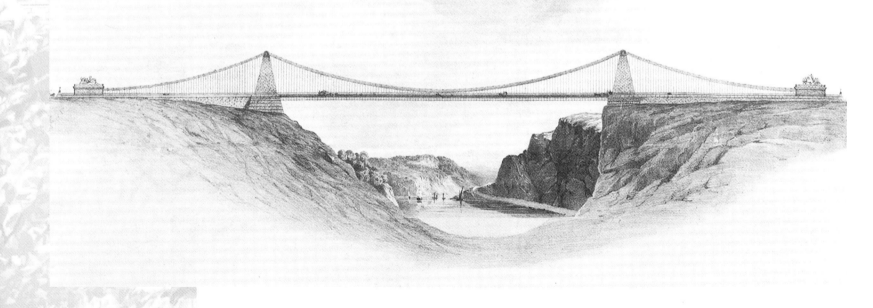

the Leigh side. For this design no expensive masonry would have been required. His other plans included medieval designs for the towers based on the gateway of Christ Church, Oxford, and Lancaster Castle, and another single-span design, but with a tower. Learning from his father's designs for the Île Bourbon bridges, all his designs had under-chains beneath the footway to make the deck more wind resistant.

The committee rejected many of the entrants' designs. Despite the requirement in the advertisement for a suspension bridge, some entries were for stone bridges, while others were unattractive or too costly.

Not feeling competent to judge engineering issues, and possible not wishing to take responsibility for a final decision, the committee approached 74-year-old Thomas Telford, the leading figure of British civil engineers, as the acknowledged expert in the field.

Made cautious by the problems with wind that were affecting his Menai Bridge, he counselled that nothing over a 600ft span was safe. Brunel's designs he wrote off: 'though pretty and imaginative [they] would certainly tumble down in a high wind.' However, he did not dismiss all entries out of hand, as has been claimed. Diplomatically, his verdict was that 'none of the designs was suitable for adoption; but that Messrs Smith and Hawkes and Mr Hazeldine approached the nearest to practical structures'. He recommended that the 100 guineas prize money should be shared between them. Brunel 'smoked away his anger', as he put it, took leave of his Bristol friends and travelled north to visit the new manufacturing towns.

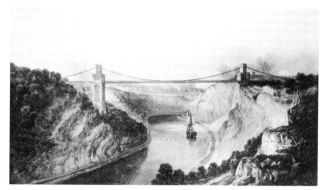

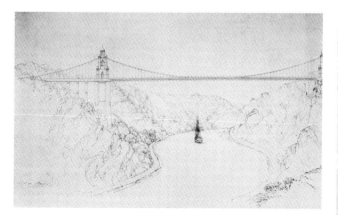

From top to bottom: Brunel stated that emerging from a 300ft tunnel in St Vincent's Rocks, the traveller would 'burst upon the splendid scene'. With a span of 980ft over the gorge it had no need for abutments. He assessed the cost of construction at £46,544. This daring scheme was by far his favourite design; Brunel's Gothic design, with towers based on Lancaster Castle and a span of 720ft; Another Gothic design, this time based on 'Tom Tower', Oxford, again with a span of 720ft. (All Bristol City Reference Library)

This left the committee in a quandary with only one possibility – to ask Telford to produce a suitable design. In less than a month Telford responded. His answer was to construct two hollow decorated stone towers in the Gothic style supporting a three-span bridge. His costing for this expensive solution was £52,000.

The committee was extremely enthusiastic, describing it as 'a monument of architectural taste and splendour, without parallel, not only in this country, but in any part of the globe'. When a lithograph showing this 'monument' was published in January 1830 Bristolians were far from sharing the committee's enthusiasm. Shaken, but not stirred, the committee issued a prospectus promising a return of 5 per cent from the tolls in return for £50 investment units. The prospectus defended Telford's design and pointed out the move westwards of Bristol's population towards Clifton, the inconvenience of ferries, greater ease of access for agricultural produce and the possibility of a pier at Portishead for mail boats and a new road link through Somerset. The committee was faced with strong disapproval of Telford's plan. Letters in the local press denigrated his design and demanded more local entrants. They now wavered, claiming that they were not necessarily committed to Telford's design. This shambles did little to attract investors. In February the investors consulted Marc Brunel, who explained to them how the effects of wind could be controlled by the use

Thomas Telford (1757-1834) was the first president of the Institution of Civil Engineers and had a national reputation. He came from a humble Scottish background and was a mason by training. He became a self-taught practical engineer and was responsible for over 1,000 miles of road as well as bridges and canals. Telford also built the Conwy Suspension Bridge in North Wales, which opened in 1826. (National Portrait Gallery)

Telford's bridge was in a Gothic style and was planned to be 210ft high with a 260ft central span. The 5ft-wide footway was in the centre between the two carriageways, as at Menai. (Private Collection)

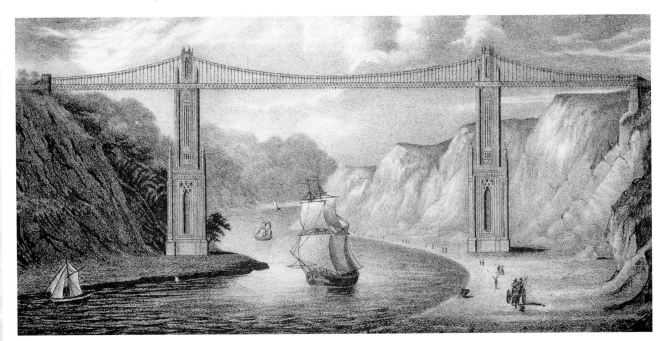

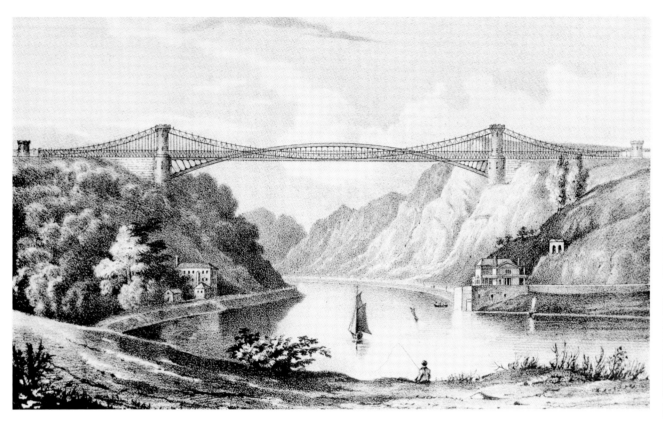

William Hill was a Bristol coach-maker. He produced two images in February 1830 using a mass of expensive ironwork. (Clifton Suspension Bridge Trust)

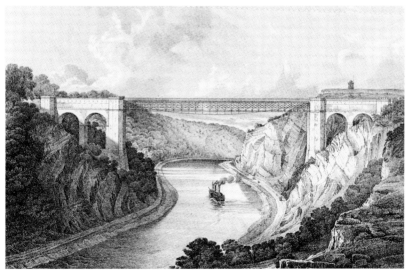

William Armstrong (1780/81–1853) was a Bristol City surveyor. He was backed by the Observatory artist William West, who published this under-chain bridge design in May 1830. (Bristol City Reference Library)

of stiffening chains beneath the deck – just as his son had proposed in his designs. During the following months, three uninvited Bristol designers threw their hats into the ring.

In May 1830 an Act of Parliament was passed permitting a chain bridge to be built, tolls to be levied and investment allowed, but the project had raised only £32,000, far short of what was needed. By October, the underfunded committee backtracked and announced that they intended to hold a second competition, stating that they had no preference whether or not the bridge was supported by pillars. The closing date was 18 December.

William Burge was a Bristolian signwriter who displayed a model of his bridge to the public in August 1830 and wrote in the local press, opposing Telford's design. (Clifton Suspension Bridge Trust)

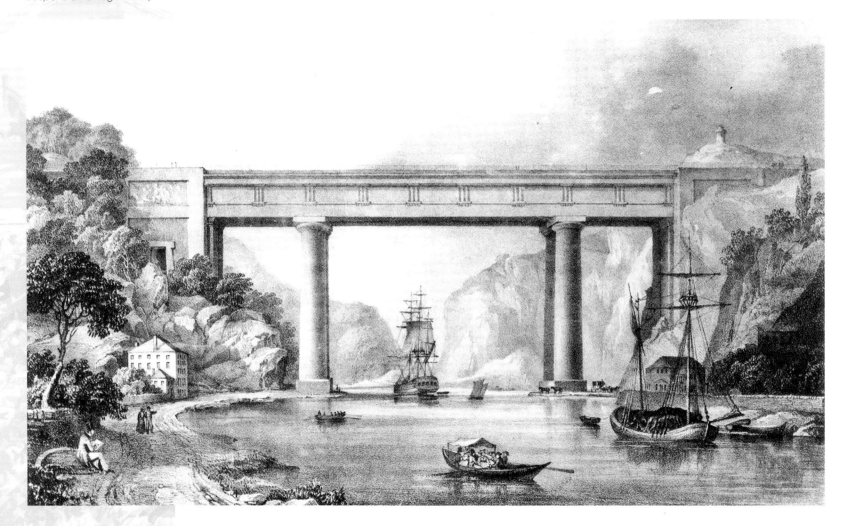

7

'APPEARING TO POSSESS SUPERIOR MERIT'

For the second competition, in 1830, the committee appointed two 'persons of science and unpartiality' to judge. These were Davies Gilbert MP FRS, who was not an engineer, but an esteemed mathematician who had sat on a Parliamentary Committee advising on the Menai Bridge. His co-judge was another mathematician, who also had expertise in iron founding, John Seward FRS.

On this occasion there were thirteen entrants, including Telford, who resubmitted his design, this time as a competitor. Other submissions whose designs have not survived were those of a Mr Savage of London (probably James Savage (1779–1852), a church and bridge builder), a Mr Dixon, a Mr I.J. Masters and a Thomas Clarke of Bridgwater of whom nothing is known.

William Burge's plans for a stone-arched bridge were rejected, as were Capper and Armstrong's chain suspension bridges. Five entrants were shortlisted as 'appearing to possess merit', including Telford's design, which was then diplomatically put aside on grounds of the cost of erecting the huge pillars.

Brunel again submitted four plans. These included three of his previous versions, including his Giant's Cave plan, on this occasion without the under-chains. As a fallback and in response to Telford's design, he included an Egyptian-style pillared design. The young engineer wrote a sarcastic letter to the committee saying that 'the idea of going to the bottom of the valley for the purpose of raising at great expense two intermediate supporters hardly occurred to me … what a reflection such timidity will cast on the state of the Arts today'. There is little doubt that Brunel was significantly aided by his engineer father, who wished to help launch his son's professional career. For several months at the end of 1830 and into the spring of 1831, and occasionally afterwards, Marc's diary makes many entries referring to his work in sending sketches, making suggestions and working to perfect the plans.

Davies Gilbert (1767–1839) helped Telford improve both the plans and the strength of the Menai Bridge. He encouraged his fellow Cornishman Humphry Davy in his career. (Private Collection)

Below: Captain Brown's design had a 780ft span and he claimed it could be built in eighteen months at a cost of £32,000. (Private Collection)

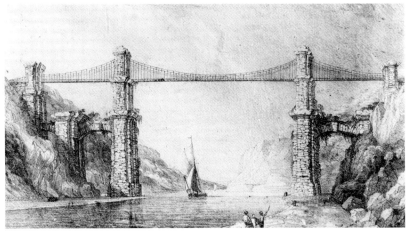

Above right: Charles Capper was another entrant from Birmingham with a rustic design which he felt complemented the rustic gorge. (Clifton Suspension Bridge Trust)

Opposite: Brunel's pillared bridge had a 360ft central span and footpaths on either side outside the carriageway, enabling pedestrians to admire the view. The plainer pillars were estimated to cost £10,000 less than Telford's. However, Brunel's heart was not in this plan, which he considered expensive and unnecessary. (Clifton Suspension Bridge Trust)

The two judges assessed only the strength and durability of the structures, leaving the committee to adopt the one that appealed to them architecturally and aesthetically. They calculated that for safety the chains should not have a maximum stress exceeding 5½ tons per square inch.

In their detailed report they criticised Rendel's 780ft span as 'very defective in the general details', criticising the road deck and saddles. At 6¼ tons per square inch it was over their prescribed limit, and was in any case too costly. Brunel's no. 3 design, with its 600ft span, had the lowest ratio at 4⅓ tons per square inch, ensuring that the bridge had 'every desirable strength and security'. They did find fault with his single pin links and clusters of chains; however, they felt the design could be amended and simplified 'with considerable advantage'.

This left Hawke's design, which at 7 tons per square inch was 'inadequately stable' but they felt that this could be amended by increasing the section of the chains by half. The judges commended Hawke's plans and approved the 'care and judgement' of his general design and the reasonable cost of his ironwork.

Both Brown and Brunel requested an interview with Davies Gilbert. Brunel convinced him that the objections he had raised could be overcome. A compromise was reached. the young engineer made changes to meet Davies Gilbert's reservations but did not record these alterations in his diary. he described the process as 'preserving struggles and some manouevres (all fair and honest however)'.

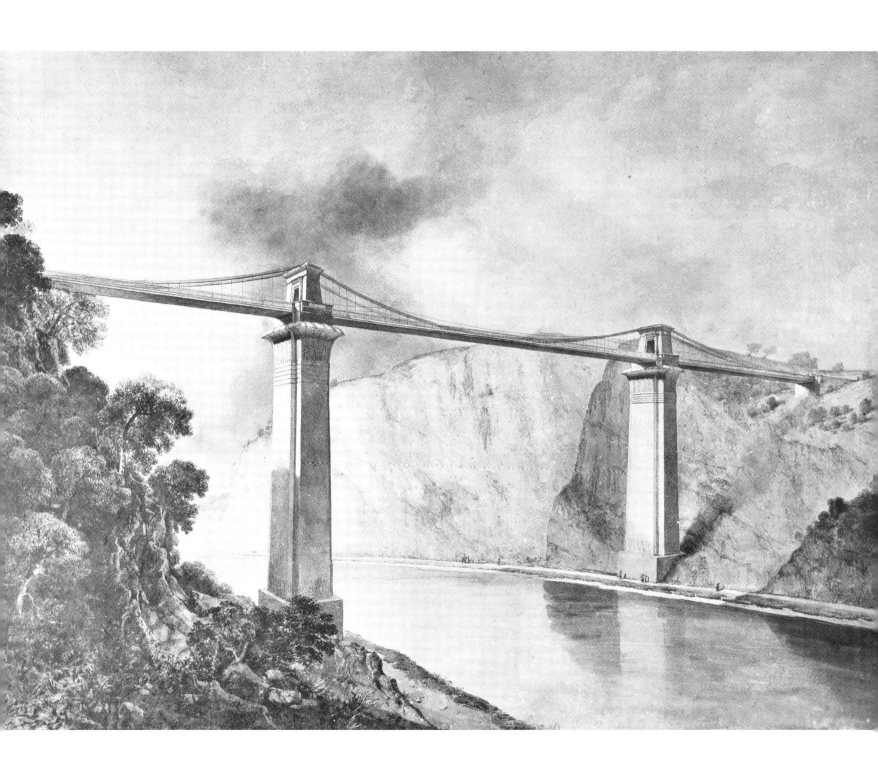

In his diary for 18 March 1831, somewhat economical with the truth, Brunel wrote: 'In the afternoon called into the Committee then DG [Davies Gilbert] having recanted all he had said yesterday I was formally appointed, congratulated very warmly by everybody.' (Courtesy of The Brunel Institute – a Collaboration of the SS Great Britain Trust and the University of Bristol)

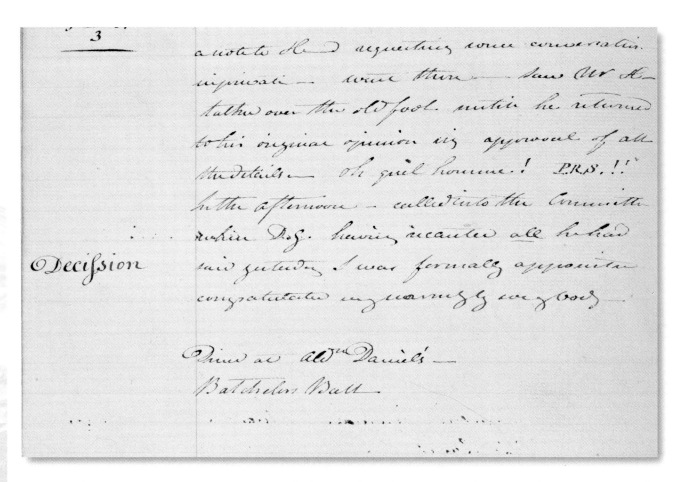

The judges met again and recommended Brunel as the winner. The committee unanimously appointed him project engineer at a fee of 2,000 guineas (£2,100) with £500 expenses and a further £1,250 for a resident site engineer and his assistant. Smith and Hawkes generously told the committee that they did not want their plans returned and that they were at the service of the committee if they could be of any help. Their plans have not survived.

Disappointed, Captain Samuel Brown wrote a furious letter to Davies Gilbert, but received a reply pointing out that those who entered competitions must be prepared to lose.

In his diary Marc Brunel wrote:

Isambard appointed Engineer to the Clifton Bridge. The most gratifying that Mr Telford, Captain Brown and Mr T Clark were his competitors and that, for my part, I have not influenced any of the Bristol people on his behalf either by letter or by interview with any of them.

The young engineer paid the leading Bristol artist, Samuel Jackson, to produce a painting of an Egyptian-style suspension bridge with an abutment, but with the towers clad in iron panels depicting each stage of the construction and crowned by pairs of sphinxes facing inwards. He later reversed them to face the entrances to the bridge.

Elated at his success, Brunel wrote to his brother-in-law and close friend Benjamin Hawes on 27 March 1831:

I have to say of all the wonderful feats I have performed since I have been in this part of the world, I think yesterday I performed the most wonderful. I produced unanimity amongst fifteen men who were all quarrelling about the most ticklish subject – taste.

The Egyptian thing I brought down was quite extravagantly admired by all and unanimously adopted; and I am directed to make such drawings, lithographs etc. as I in my supreme judgement may deem fit; indeed they were not only liberal with their money, but inclined to save themselves much trouble by placing complete reliance on me.

8

'THAT STUPENDOUS WORK, THE ORNAMENT OF BRISTOL'

On 20 June 1831 a rather bizarre ceremony took place on the Clifton side of the river. At noon, after a public breakfast at the nearby Bath Hotel, the committee and their ladies proceeded to a circle of stones, newly excavated to mark the start of the project. 'Respectable inhabitants of the neighbourhood ... and a considerable number of females of rank and fashion' were reported present.

Brunel entered the circle and presented one of the stones to Lady Elton, wife of a local dignitary who wished success to the task. Immediately, there was a volley of cannon fire from the height of the rocks, followed by the band of the 3rd Dragoon Guards playing the national anthem. The Union flag on a temporarily erected flagstaff was hoisted.

Sir Abraham Elton expressed his confidence in the success of the project both for its utility and as an addition to the beauty of the gorge. He claimed that he could anticipate the time when 'as that gentleman walked the streets, or as he passed from city to city, the cry would be raised "There goes the man who reared that stupendous work, the ornament of Bristol and the wonder of the age"'.

During the ceremony, a toast to 'the undertaking and its conductor' was drunk with champagne, while the 'humbler classes' were regaled with a barrel of beer.

Less than a week before the ceremony, the committee had considered that continuing the development with a shortfall of £20,000 of the £52,000 required was 'bold and hazardous', but three days later one of their members persuaded them unanimously to go ahead. This lack of notice meant that there was little opportunity for publicity for the ceremony and many irate letters were received by the local press bemoaning this when full reports of the event were given.

Felix Farley's Bristol Journal did more than report the ceremony – they pointed out the advantages that a bridge would bring. With the increasing population of West Bristol, land values on the Somerset side would increase and make easier access for agricultural products to be brought into the city. The bridge would make for more direct communication with Gloucestershire, Bridgwater and South Wales, while a pier for a mail steam packet would make links with Southern Ireland. Finally, a bridge would allow a shorter and more level route into Somerset than then existed.

In the same edition the committee's solicitors placed an advertisement 'respectfully informing the public' that subscription books had been placed in banks, the Hotwell Pump Room, hotels and libraries 'in the confident reliance upon the liberality of the Public'.

In October 1831 the landowner on the Somerset side, Sir John Smyth, rejected an offer of £1,200 for the 4 acres of land required for access to the bridge. An enquiry held under the terms of the Act awarded him £1,007 for the land and £100 for damages, just £93 less than he had demanded. Preparatory work began.

Four months later disaster struck.

This trade card shows the Bath Hotel, which was frequently used by Brunel when visiting Bristol and, although much altered, is still standing. (Reece Winstone Archive)

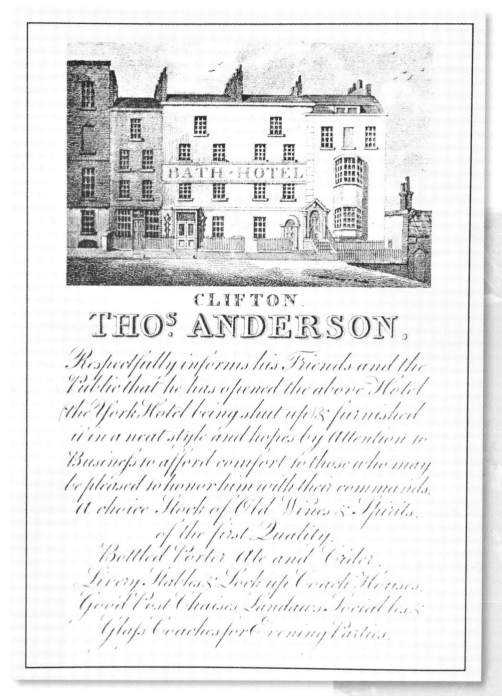

9

'DANTE'S INFERNO'

For three days in late October and early November 1831 a mob totally controlled the city of Bristol. It began when Sir Charles Wetherell, the Recorder or local judge, arrived to take the assizes. He was also a Member of Parliament and had recently voted against the Reform Bill, which would have allowed a greater number of people to vote. Feelings ran high in the city and there was a flourishing society in favour of reform of the 'rotten boroughs' – those with only a handful of voters in the pocket of a local landowner. However, unlike the growing northern towns, Bristol returned two Members of Parliament, despite the fact that only 3 per cent of Bristol's male population were entitled to vote.

As he approached the outskirts of the city, although guarded by constables and hired thugs, the terrified judge, huddled in the corner of his coach, was hissed, booed and groaned at by a crowd of between 1,000 and 2,000, and his coach was pelted with mud, stones and rotten eggs. Wetherell hastily declared the assizes open and moved on to the Mansion House in Queen Square, home of the mayor. A wholesale uprising developed, especially when the well-stocked cellar of the Mansion House was broken into and 7,000 bottles of port, sherry and Madeira were looted as well as furniture, mirrors and chandeliers. The drunken mob also set fire to the Mansion House, and Wetherell escaped over the rooftops, exchanging clothes with a coachman and fleeing to Newport. Over the following days the rioters set fire to the custom house and two sides of Queen Square, before moving on to destroy the Bishop's Palace (the bishop had also voted against reform in the House of Lords), the Chapter House with its 6,000 books, toll houses, the newly built gaol, the Bridewell and the Gloucester prison to the east of the city. Some of the drunken rioters perished, caught in the melting lead on roofs in the fires while looting. Over 100 houses were destroyed and it is claimed that the flames could be seen from 40 miles away. The cathedral was saved by the bravery of a sacristan who defied the rioters.

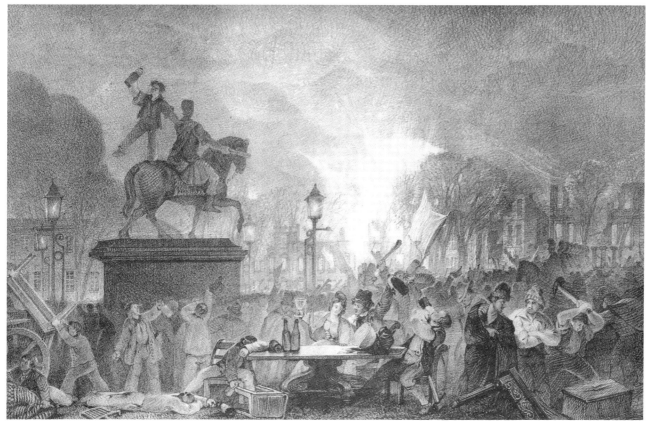

Not since the Gordon Riots in London fifty years previously had so much damage been done as in the Bristol Riots. The drunken rioter on the statue of King William III in Queen Square and the mob around him epitomise the riots. (Bristol Museums, Galleries and Archives)

The author Charles Kingsley described the charred corpses in Queen Square thus: 'One seemed to look down on Dante's Inferno.'

The council and magistrates, 'bewildered and stupefied with terror', either dithered or found urgent business elsewhere, incapable of any concerted plan of action. Only a few of the middle classes, who by and large also detested the self-perpetuating and arrogant oligarchy that formed the council, enrolled as Special Constables and were prepared to save what was commonly seen as council property. Brunel, however, volunteered and, according to his granddaughter's biographical account, arrested a man, who later escaped.

It was only with the arrival of a regular army cavalry unit, which made repeated charges, that the riots were finally put down. Estimates of the loss of life vary from 100 to 250, while the damage to the city was immense – the Bristol Riots were the worst example of civil unrest in the nineteenth century. Eventually four rioters were hanged, thirty-three transported to Australia and forty-three sentenced to hard labour for various periods. The commander of the

local yeomanry, who had been insufficiently robust in his attempts to quell the mob, committed suicide during the course of his subsequent court martial, at which Brunel gave evidence, but the mayor and magistrates avoided any serious censure.

Amongst the many effects on the city was that business confidence was shattered and work on the bridge ground to a halt just four months after it had begun. It was to be another five years before a start on actual construction was made, with funds still short. By that time Brunel's career was flourishing; he had been appointed Engineer for the Great Western Railway, worked for the Bristol Docks Company and was the engineer for the transatlantic paddle ship *Great Western*, which was being built in Bristol.

10

'MY FIRST CHILD, MY DARLING'

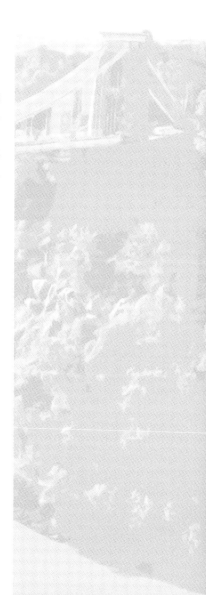

Eventually business confidence returned – rather more swiftly for viable projects promising good returns on investments than for others. Compensation for losses during the riots and, following the Abolition of Slavery Act of 1833, for those with an interest in the slave trade, meant that money flowed into the city within eighteen months to two years of the riots. Local investment went mainly to the Great Western and Bristol & Exeter railways, as well as to the paddle steamship *Great Western* and the newly established Great Western Cotton Company.

The committee were still desperately short of funds, despite fresh appeals, and considered less expensive options. William West, the artist in the Observatory, had visited the continent and had been impressed by the span of the Fribourg Bridge cables, which had been built at a cost of £23,000. West had also inspected fourteen bridges in France, nine of them using cables. He became convinced that wire was 'in the essential qualities of economy, strength and durability greatly superior'. In January 1835 he approached the trustees, produced a model and gave several lectures on the subject, gaining some local support.

Seizing on this, the trustees wrote to Brunel seeking his opinion. In a display of magisterial expertise he replied that he knew the French manufacturer of wire, and that wire was four times as expensive as iron, nothing like as strong and prone to corrosion. At a subsequent conference where both sides set out their views, Brunel completely disagreed with West, who was politely thanked and awarded 30 guineas for his efforts. Brunel was aware of the difficulty in raising funds and offered to design a bridge that would be equally strong and capable of being extended when money was available. At the trustees' request he produced a plan using smaller and lighter towers without their ornaments, abandoning the two footways and reducing to one chain only. This he estimated could be achieved for £35,000. To their credit, the trustees decided

The Fribourg bridge in Switzerland was built in 1834. Using wire cables, it had a record-breaking span of 830ft at a cost of £23,000. (Private Collection)

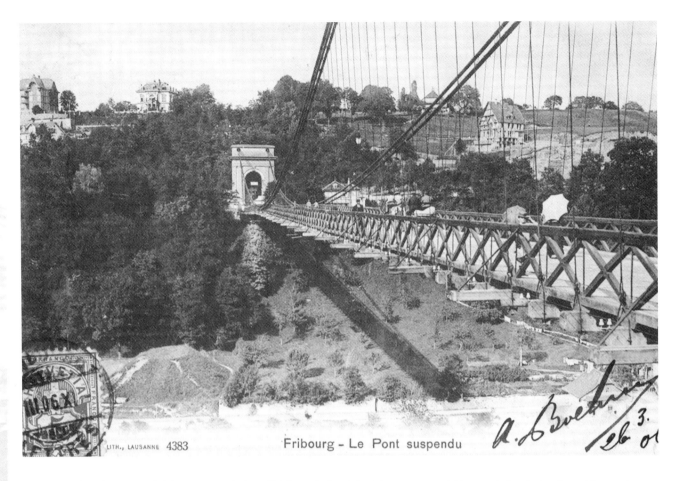

LITH., LAUSANNE 4383 Fribourg – Le Pont suspendu

that the bridge would be too 'minimalist' and decided to support the original design. Brunel was requested to prepare plans for the Leigh abutment.

In his diary on Boxing Day 1835 Brunel noted that being appointed engineer to the bridge had led to him being currently responsible for projects worth £5,000,000. One of the projects he listed in his diary was the Hungerford footbridge across the Thames. He noted, 'I shan't give myself much trouble about it.' Nevertheless, the Hungerford bridge was later to play a vital role in the story. The young engineer also wrote: 'Clifton Bridge – my first child, my darling is actually going on – recommended last Monday – Glorious!'

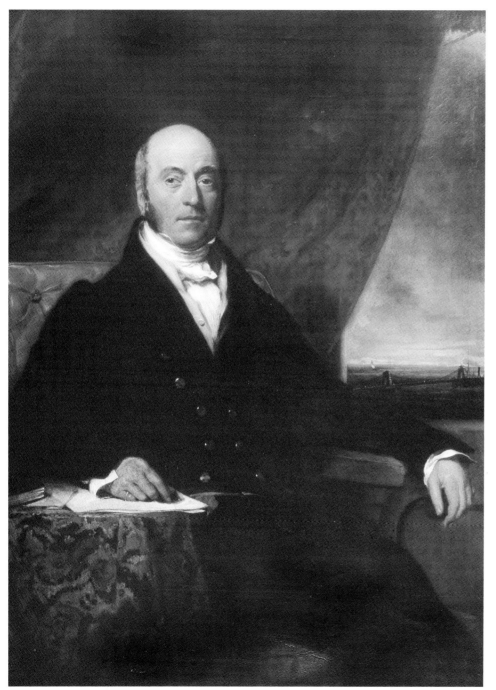

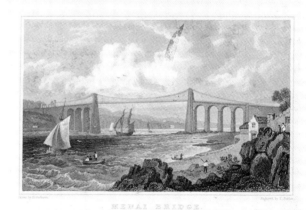

Clockwise from left: Captain Samuel Brown RN (1776–1852), builder of the Union Chain Bridge. It attracted many visitors when it opened in 1820, including 18-year-old Isambard, who came with the eminent French engineer Charles Navier, and was followed within a month by his father Marc. (Royal Pavilion and Museums, Brighton and Hove); Using the principles of ships' rigging, Captain Samuel Brown patented his chain links invention and defended it vigorously. (Private Collection); Thomas Telford's Menai Bridge, linking the mainland and Anglesey, inspired immense national pride and international interest, and speeded communication with Ireland. (Private Collection)

11

'NOTHING WAS WANTING TO GIVE ANIMATION TO THE CEREMONY'

The foundation ceremony on 27 August 1836 could not have been more unlike the low-key event of five years before. This time it had been widely advertised. A viewing stand, 'being the best place for witnessing the ceremony', was erected and tickets were sold.

The ceremony was performed by the Marquess of Northampton, President of the British Association for the Advancement of Science, which fortuitously was holding its conference in Bristol. It was timed to begin at 7.30 a.m., to take advantage of a high tide and to avoid affecting the conference schedule, and it is reported that by that time 60,000 people were present.

Again, unlike the previous ceremony, as the *Bristol Mercury* reported, the ceremony 'drew together tens of thousands of the inhabitants of the city and its neighbourhood. As far as the eye could range, from the banks of the river to the summit of the stupendous rocks, indeed, wherever footing could be found, dense masses of spectators had posted themselves.' In the river below were vessels ranging from steamers to the smallest wherries and displaying 'all the colours [flags] they could muster'. The marquess arrived on the Somerset side of the river in a carriage drawn by six grey horses, with his postilions wearing crimson silk jackets and black caps with gold tassels, and led the procession, along with Brunel, who carried a copper plate, a silver trowel and a mallet. They were followed by 400 of the committee members, subscribers, conference members, councillors, and other dignitaries and 'men of science' – including Marc Brunel, on his first visit to Bristol – walking four abreast down a flight of flag-bedecked wooden steps to descend 100ft down the side of the gorge to a large platform. This adjoined a ramp that went to the foot of the gorge and would later be used as a hauling way.

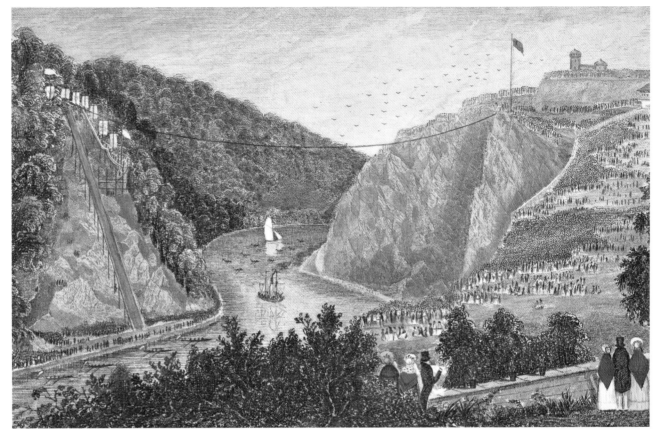

The ceremony for the laying of the foundation stone. The river is shown as crowded with vessels and the cliffs and riverbanks with thousands of spectators who had come to witness the event. (Bristol City Reference Library)

A time capsule containing coins currently in circulation, from 2 guineas to a farthing; a copy of the Act of Parliament; and a plate with an image of the bridge, part of a specially made service used at the public breakfast held at a local hotel, were placed in a specially excavated cavity in the rock. On top of the capsule was laid a copper plate outlining the event and Vick's contribution and giving the dimensions of the bridge. The Marquess then spread mortar over the plate with the silver trowel and tapped it with the mallet. A foundation stone was lowered into place, upon which trumpets sounded and cannon fired to resounding cheers. A local schoolmaster and his pupils released three green balloons painted as globes and two larger white ones with the banner 'Success to the Undertaking' attached to them. After speeches, the national anthem and 'Rule, Britannia!' were played and the guests adjourned to their banquet at the Gloucester Hotel.

In the words of the *Bristol Mirror*, 'Nothing was wanting to give animation to the ceremony'.

'WORKING LIKE THE DEVIL'

Brunel had earlier compared the gorge to the Simplon Pass, which may account for his 'Swiss Cottage' site office. In this image, celebrated local artist Samuel Jackson is drawing the scene. After the opening of the bridge in 1864, another much larger Swiss-style house, 'Alpenfells', was built on the Leigh side, overlooking the gorge, and can still be seen. (Private Collection)

While most engineers would have been satisfied with a rough shack on the site, Brunel decided to construct something that resembled an Alpine chalet, known as the Swiss Cottage. The first floor was his office. A balcony and windows overlooked the site, and there was a space below for storage of material.

In order to move men and materials from one bank of the river to the other, Brunel designed a wicker basket suspended by pulleys from an iron bar, 800ft long and 1½in in diameter. The basket ran by gravity down to the centre of the bar and was then hauled across the remainder by ropes from the opposite side. The bar was forged on the Somerset side. In August 1836, men turned a capstan over the course of two days to haul it across to the Clifton side, and it was then secured to loud cheers. These turned to groans as the hawser snapped and the bar plunged down to the foot of the gorge. Nevertheless, by the following day the workmen had the bar back in place and firmly secured. However, in its fall the bar had acquired a kink that prevented the free running of the pulleys. Brunel, who was testing it first, tried swinging the basket to and fro without success. He then climbed out, watched by a crowd of onlookers, and, 'with seeming composure', released the car while swinging over 'this tremendous chasm'.

By October a new bar, this time 2in in diameter, was forged and Brunel again tested

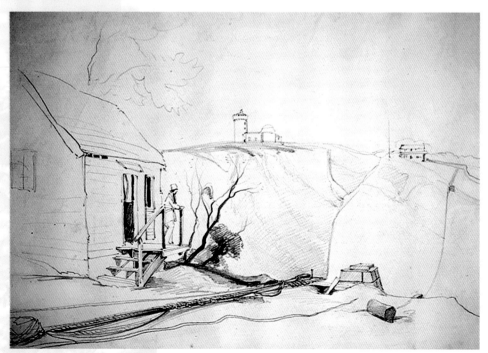

it, accompanied by a young boy, Master Claxton. He then made two more crossings, 'accompanied by a gentleman on each occasion'. It worked perfectly.

When not required by the contractors, the public could pay to cross the gorge in the basket. During one Somerset wedding, the bridegroom, 'having had enough cider to make him adventurous, persuaded the not-unwilling bride to make the flying passage'. At the centre of the bar the rope broke and there they swung for several hours, their friends shouting from the abutment that they would have to spend their wedding night in the basket. A new rope was eventually found and the couple were hauled to safety.

In the general election of 1852, after work on the bridge had ceased, political rivals slid an effigy of a right-wing Tory parliamentary candidate, Foster Alleyne McGeachy, down to the centre of the bar with a placard reading 'Alas! Poor McGeachy'. It hung there for three days and could not be reached. His supporters' only alternative was to find sharpshooters to sever the rope from which it hung by rifle fire. This was finally achieved after eight shots. Accounts vary – was it a local gunsmith or a gamekeeper from the nearby Ashton Court Estate who fired the final shot? Poor McGeachy was defeated in the election.

Although the 300ft hauling way on the Leigh side enabled 2 tons of masonry to be lifted at a time, work on the massive abutment went slowly. In less than nine months the contractors became bankrupt.

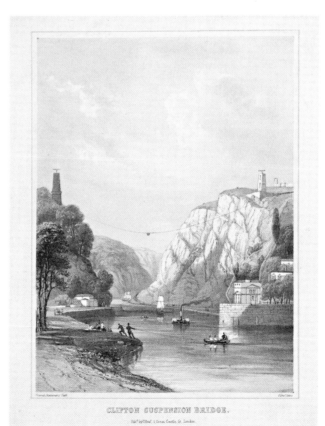

CLIFTON SUSPENSION BRIDGE.

Clockwise from left: A piece of the second bar has been preserved and is now in the Suspension Bridge Visitor Centre. (Clifton Suspension Bridge Trust); Thankfully, some young ladies in the nineteenth century had a knowledge of botany. As the clearing of the ground for the bridge began, Mrs Glennie, the wife of one of Brunel's engineers, pointed out a rare plant, the autumn squill (Scilla autumnalis), which lay in the path of the approach road. Brunel obligingly had some the bulbs removed to safety. It is one of the many rare plants to be seen in the Brunel Garden at the Clifton entrance to the bridge. (Phil Jeary); The scale of the basket is frighteningly small when compared with the depth of the gorge and the length of the bar. (Bristol City Reference Library)

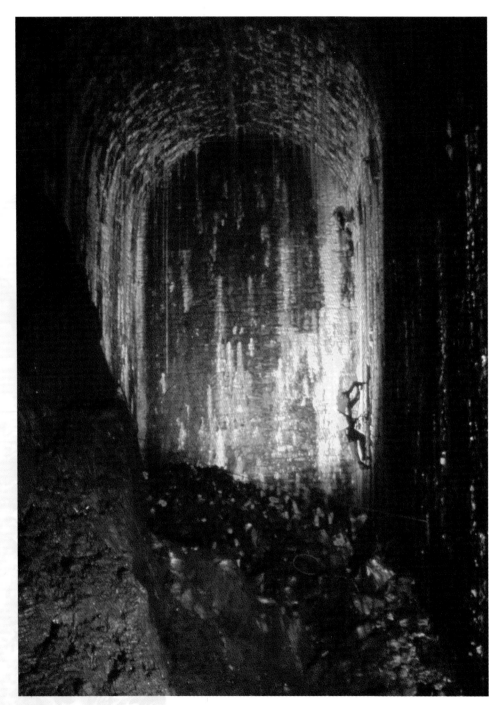

The committee took direct control and Brunel left his other projects and 'working like the devil', as he put it, re-employed the labourers and superintended the project in person, finding that the foundations were set 3in out of alignment.

Construction was further hindered by some of the coldest weather for 200 years. A letter to the local press in November 1837, signed by 'AA', said that the author had regularly viewed progress through his telescope on Observatory Hill and that he calculated at this rate of progress, 'The bridge will be passable on the morning of 30th June in the Year of our Lord One Thousand Nine Hundred and Eighty-Seven!'

The slow progress once again caused others to come forward with alternative plans. Bristol tea dealer, grocer and bridge designer Thomas Motley produced a design described by Brunel as 'objectionable'. This was followed in 1838 by a proposal form James Dredge, which used 'patent tapering chains'. The committee sought a meeting with Brunel to ask his opinion of this design; Brunel does not appear to have responded to the request.

The sandstone-clad Leigh abutment was finally completed in early 1840. Its core was of stone from a quarry bordering the river downstream. The cost was £10,142, far more than Brunel's original estimate of £8,000, and it had taken thirty months to complete, double his calculated timescale of twelve to fifteen months. Telford's cautious warnings about the longest possible length of a span

had caused much of the funding to be spent on an expensive abutment. Construction of the smaller abutment and the lower part of the Clifton tower then began, and both abutments were completed by 1843. The anchorage pits were dug and cranes erected on top of the towers to lift the ironwork. All was now ready for what was intended to be the final phase.

Opposite: Even now how many travellers stopping at the Leigh toll realise that this vault is the upper one of two directly beneath them? There was widespread surprise when it was discovered that below the Leigh abutment was a honeycomb of twelve huge vaults in two tiers. It had always been assumed that the 110ft-high abutment was solid masonry. A borehole investigation in 1969 happened to go through the solid part of the structure. None of Brunel's contract drawings have been found to date. Two small thumbnail sketches indicate that the abutment was constructed with voids to reduce the costs of labour, quantity of materials, construction and drying out time. (The towers of the Menai Bridge were also hollow.) In 2002 the trustees decided to find out more about the internal condition of the abutment after a 50ft-deep shaft had been found beneath the Clifton tower a couple years previously and was thought to be part of a drainage system. Modern electronic surveys showed the possibility that there was a shaft beneath the footway on the Leigh side – excavation revealed that there was, and abseiling specialists then discovered the tunnels leading to the chambers. The largest chambers have a floor size of 57ft x 18ft and are 35ft high (the height of three double-decker buses) linked by tunnels 2ft wide. The chambers are festooned with stalactites 13ft long. (Clifton Suspension Bridge Trust)

13

'A TROUBLESOME ORDER'

While most of the Pennant stone for the abutments and towers had been sourced locally, the iron had to be imported from elsewhere and was the most expensive element in the construction of the bridge. Oddly, no local ironworks tendered. Brunel ordered 600 tons of bar iron from the Dowlais Iron Company of South Wales. Initially Dowlais considered that his precise and specific insistence on quality standards would make it 'a troublesome order', but he managed to persuade the company to provide the required materials and even to lower the price. From South Wales the iron was then shipped to the Copperhouse Foundry in Hayle, Cornwall, which was to forge the iron into the chains as well as manufacturing the saddles and anchorage plates. Again, Brunel's insistence on quality meant that his beady-eyed agent in Cornwall was rejecting what Copperhouse saw as an unreasonable amount and the company made a complaint.

For some time the committee had been encountering difficulty in collecting the promised donations and loans, and the project had now completely outrun the available funds. In 1843 Brunel was instructed to order Copperhouse to halt any further production. It was now estimated that no less than £36,348 was need for completion. Solutions were desperately sought. The receipt from the tolls was offered to the contractors, who declined. A Treasury loan was also offered, but none of the committee was prepared to be personally responsible for underwriting the £15,000 loan. Brunel resurrected the proposal of constructing a deep-water pier at Portbury, thus making the bridge an essential link, a scheme that had been suggested by various engineers on several occasions. None of these proposals bore fruit, due to entrenched interests in the city docks. Having waited in vain for payment, and even offering to reduce the amount owed, the Copperhouse Foundry eventually issued a writ for £3,349. The committee procrastinated but finally raised a loan, paid off Copperhouse and, after further attempts by Brunel to find means

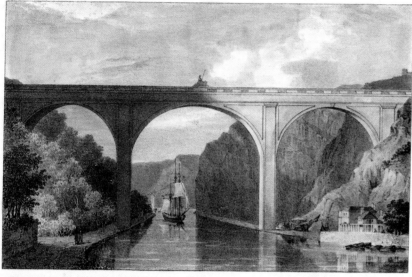

Height of Roadway from High Water 210 ft.
Width of Roadway 20 ft.
Footways each 5 ft.

Span of Centre Arch 200 ft.
Side Arches each 160 ft.
Estimated Cost £ 30,000

Published by J. Wright, 18, Bridge Street, Bristol.

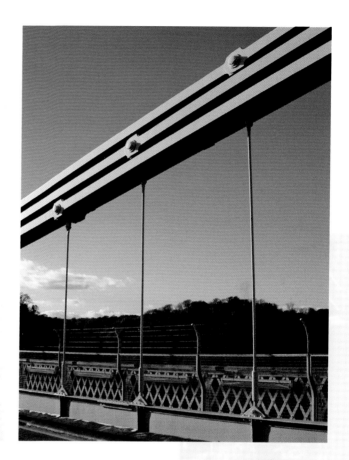

to complete the bridge, in 1853 ordered the sale of the ironwork to cover the debt. The iron bar across the gorge and other materials were sold off, including the cranes and Brunel's site office, the Swiss Cottage, which was disposed of for a mere £5. The land, which had been donated by the Society of Merchant Venturers, was reclaimed by them.

Ironically, the chain links which were on site were sold to the Cornwall Railway Company for less than 10 per cent of the actual cost and were used in the construction of Brunel's Royal Albert (railway) Bridge, linking Devon and Cornwall at Saltash, which opened in 1859.

Above left: Willam Young, a local mason whose design had not been accepted earlier by the committee, published a print of his design in 1835, claiming that it would cost 'not exceeding £30,000'. He criticised suspension bridges as having 'no pretence to magnificence' and needing costly maintenance. (Private Collection)

Above right: Brunel preferred his own version to that of Captain Brown. (Private Collection)

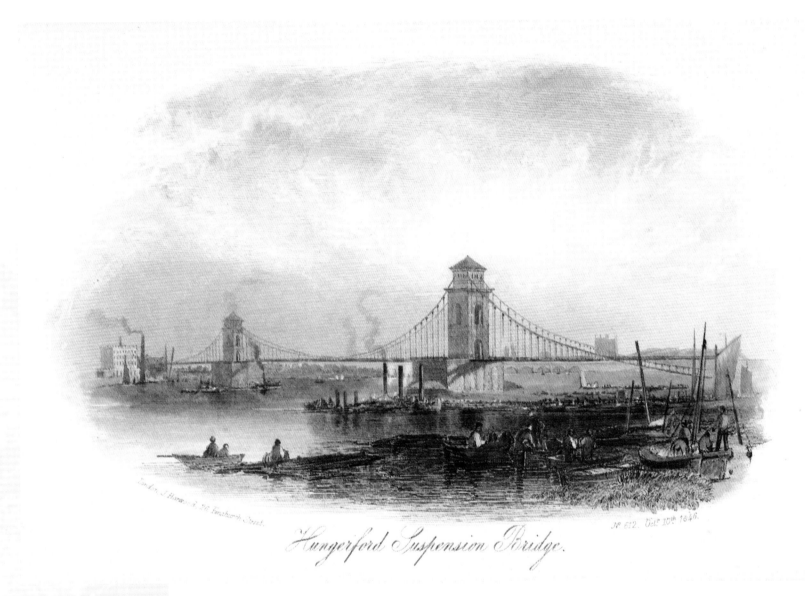

Hungerford Suspension Bridge.

Brunel used the same ironwork foundry, Copperhouse at Hayle, Cornwall, for both his Hungerford footbridge and for Clifton. (Private Collection)

14

'COMPLETING THE BRIDGE IS NOW WHOLLY ABANDONED'

Yet again, in 1851 someone came forward with an idea to complete the project. On this occasion it was Lt Col E.W. Serrell, engineering consultant to the United States Government. In 1851 Serrell had built a bridge at Niagara, linking America and Canada, with a span of 849ft, using wire cables. He was convinced that the bridge could be finished in fifteen months at a cost of only £7,400. A new committee was formed, proposals developed and an Act of Parliament drafted. Brunel was consulted. Serrell's use of iron wire cables and his narrow roadway with a width of just 19ft caused Brunel to comment on its 'flimsiness', but probably despairing of ever seeing a bridge built, he declared that he would not oppose it.

Others commented that the whole construction proposed was 'of the slightest kind'. For six years, negotiations dragged on. Serrell offered to use imported or local labour as the committee demanded. Twice he upped his estimate, eventually reaching £17,000. However, the committee eventually dropped the idea and paid Serrell £90 'for his trouble'. The following year Serrell's suspension bridge at St John's, Newfoundland, collapsed. His Niagara bridge gave way after a severe storm in January 1862.

At Clifton the two towers became a constant reminder – 'monuments to failure', as one correspondent described them in the local press. This same commentator also declared that 'completing the bridge is now wholly abandoned'. An article in the *Bristol Mirror* bemoaned '£45,000 spent on purposeless excrescences'.

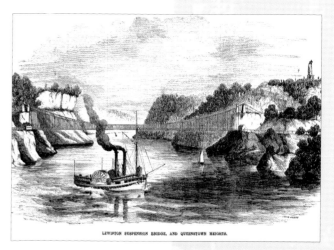

Colonel Serrell's Queenston–Lewiston Bridge at Niagara was built in just eleven months using wire cables, which he claimed were impervious to the elements. The design echoed Brunel's favourite scheme, with the cables anchored into the cliffs. (Private Collection)

LEWISTON SUSPENSION BRIDGE, AND QUEENSTOWN HEIGHTS.

The gaunt, abandoned towers were considered by most Bristolians as a blot on the landscape, a waste of money and a reproach to the city. Bristol City Reference Library)

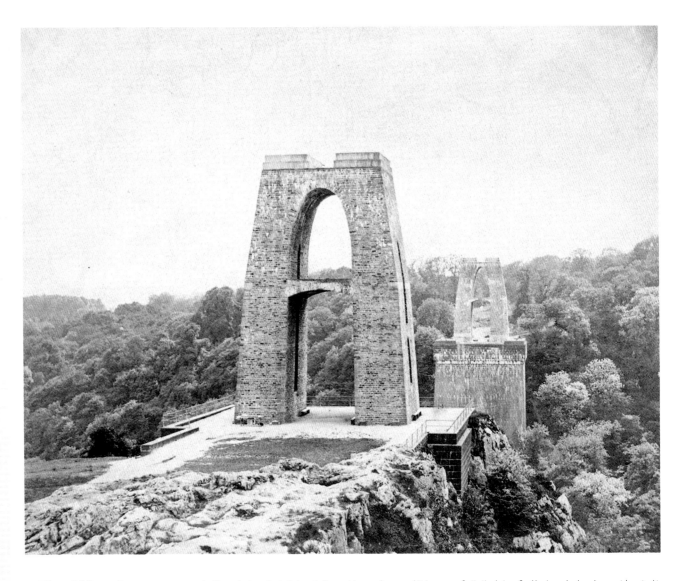

The Clifton Improvement Society lobbied for the demolition of 'Vick's folly', claiming that it spoiled the natural beauty of the gorge, and received widespread support.

In September 1859 Brunel suffered a stroke, the day before the sea trials of his *Great Eastern* vessel, and died six days later at the age of 53, worn out by overwork and the stress caused by the construction and launching of the largest vessel in the world. He was also suffering from Bright's disease, a kidney condition leading to renal failure.

Strangely, it is owing to the engineer's death that we have a bridge today.

15

'IN EVERY RESPECT PERFECTLY SATISFACTORY'

In early 1860 two of Britain's foremost engineers, John Hawkshaw FRS and W.H. Barlow FRS, wrote a report demonstrating that the chains of the Hungerford Suspension Bridge in London could be used to complete much of the Clifton bridge. The Hungerford bridge, the only pedestrian suspension bridge in London, had been built by Brunel and opened in 1845. Now it was about to be demolished and replaced by the Charing Cross railway bridge, designed by Hawkshaw. This coincided with a resolution at a meeting of the Institution of Civil Engineers, who wished to finish the bridge as 'a fitting monument to their late friend and colleague'. They also felt strongly that the uncompleted structure was a reproach to British engineering skills.

After this, events moved swiftly. A new committee was formed, a new Act of Parliament quickly secured and within twelve months £30,000 towards the estimated cost of £45,000 had been raised. The landowner on the Leigh side, Sir Greville Smyth, conscious that completion of the bridge meant that his land value would become the highest in the area, offered £5,000 on condition that the roadway was widened to 31ft, and this was included in the Act. In return he was exempted from tolls for thirty years.

The Hungerford Bridge ironwork was acquired for £5,000 and fittingly brought to Bristol on Brunel's Great Western Railway. Cochrane and Grove of Dudley, Warwickshire, were appointed as contractors, overseen by Hawkshaw and Barlow.

The two engineers made several fundamental changes to Brunel's original design. Two girders were made to run the length of the bridge for stiffening, and Brunel's cross-girders of timber and iron were replaced by wrought-iron versions. The wider and heavier deck necessitated a third chain with a rearrangement of the suspension rods. In addition, the length

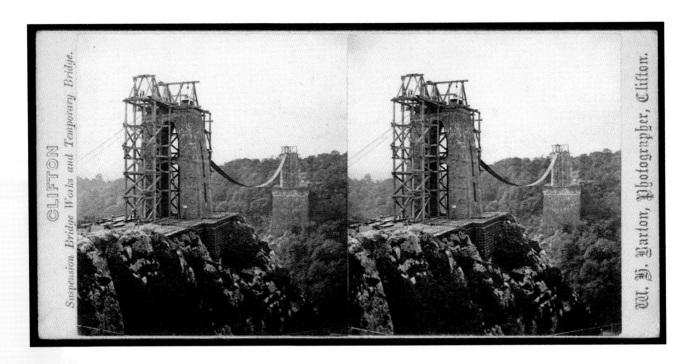

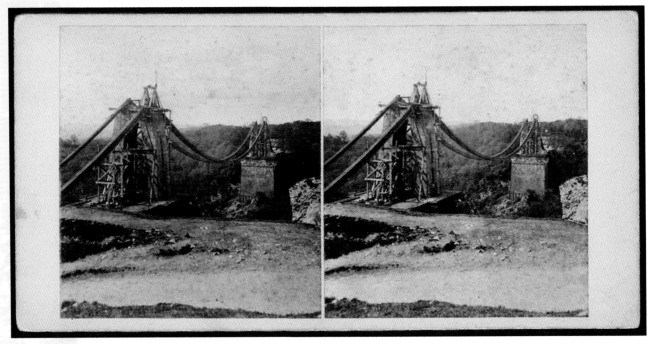

of the chains on the landward side was reduced, avoiding the need for suspension rods. The roadway was increased in height from 230ft to 245ft above high water. Finally, the cast-iron decorative panels proposed by Brunel for the towers, and the sphinxes upon them, were dropped to save expense.

Work began in November 1862, with Thomas Airey as Cochane and Co.'s resident engineer. Four months later a huge wooden scaffolding enabled the saddles with their rollers from the Hungerford bridge to be mounted on the towers. Erecting the falsework then began. Eight wrought-iron cables were strung between the towers and wooden planks lashed to them to form a walkway. Above these ran two more cables, which acted as handrails and allowed two grooved-wheeled 'cradles' to hold the chains while they were installed. Above this again was a 'traveller', a light-framed cart that carried the chain links.

Work proceeded apace. By summer 1863 the anchorage tunnels and plates were in place 60ft underground, with the base fanning out and held by blue Staffordshire bricks. The assembling of the chains then began. After the first chain was complete, the second was installed above it and the third above that at a rate of forty links a day. The operation was then repeated on the opposite side until all six chains were in position by May 1864. By July the road deck was completed. Finally, the toll houses and approach roads were completed.

Before the completion of the road deck, some members of the British Association for the Advancement of Science were allowed to cross on planks. The party included the explorer Dr Livingstone and the industrialist Sir William Armstrong. One member of the group was blind and asked searching questions about every item of the structure.

The next phase was installing the roadway. This was accomplished using two cranes with long jibs working simultaneously from either

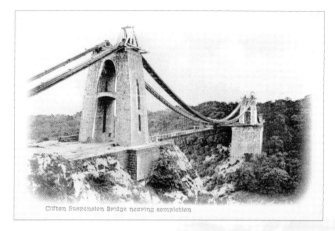

Clifton Suspension Bridge nearing completion

Opposite and above: These April 1863 stereoscope views show the wire cables in and falsework completed. (Private Collection)

Below: In this image, taken from the Clifton tower in Spring 1864, a jib crane is lifting a girder for installation. (Clifton Suspension Bridge Trust)

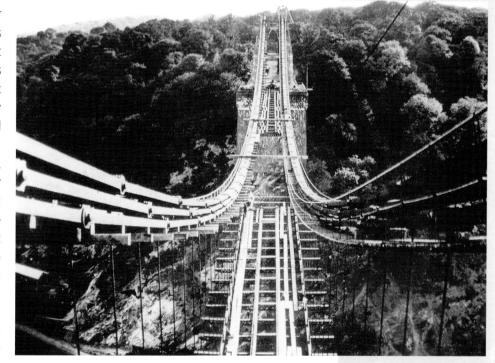

side, these cranes moved 40ft-long sections of the iron longitudinal girders to where they could be connected to the suspension rods. Once the roadway was joined, paving blocks of Baltic pine were placed on top, with a second tier at right angles above them. By the summer the approach roads were prepared and the bridge painted. The project was completed on time and on budget, with just one recorded fatality.

In November 1864 the Board of Trade carried out a safety inspection, with 500 tons of stone spread across the span of the bridge in order to test its ability to carry the weight. The deck drooped by a mere 7in and resumed its former position once the stones were removed. The Board's report said that the bridge was 'in every respect perfectly satisfactory'. The Leigh tower had yet to be capped but the date could now be set for the grand opening ceremony.

16

'THE CHASM HAS BEEN SPANNED'

Fortunately Thursday 8 December 1864 – declared a public holiday – dawned dry, despite very heavy rain the night before, encouraging thousands to flock to find the best vantage points. Church bells pealed out as a grand procession marched across the city through flag-bedecked streets, in strict order, marshalled by a North Somerset Yeomanry sergeant major. The mile-long parade, liberally interspersed with bands, consisted mainly of local military volunteers, tradesmen (many carrying 'models of their trade') and friendly or benefit societies. In all it took forty-five minutes to pass one spot. Amongst the dozens of trades represented were manufacturers of iron beds, cork cutters, gold beaters and coachbuilders. The members of United Ancient Order of Druids Benefit Society caused much amusement when they hoisted their long robes, much like nightgowns, to avoid the muddy streets, revealing knickerbockers beneath!

The trees on both banks were decorated with flags. A grandstand to hold 1,200 people had been erected for paying spectators near the entrance to the Clifton toll house, and a stand for the dignitaries had been set up opposite. The towers were covered in widely admired greenery, shields and flags. Although an estimated 150,000 people had flocked into the city from the surrounding area, local papers remarked rather acidly that the ceremony had 'failed to draw to the city any member of the reigning family', the prime minister or any member of the Brunel family. Henry, Brunel's youngest son, claimed that 'the whole thing feels quite independent of honouring memory'.

The VIPs, principally made up of clergy, diplomats, MPs, magistrates, members of the Merchant Venturers, civic officers and shareholders,

This two-horse plough was carried in the procession on opening day by George Flook, representing Messrs A. & T. Fry, wheelwrights and agricultural engineers. (Courtesy of the SS Great Britain Trust and the University of Bristol)

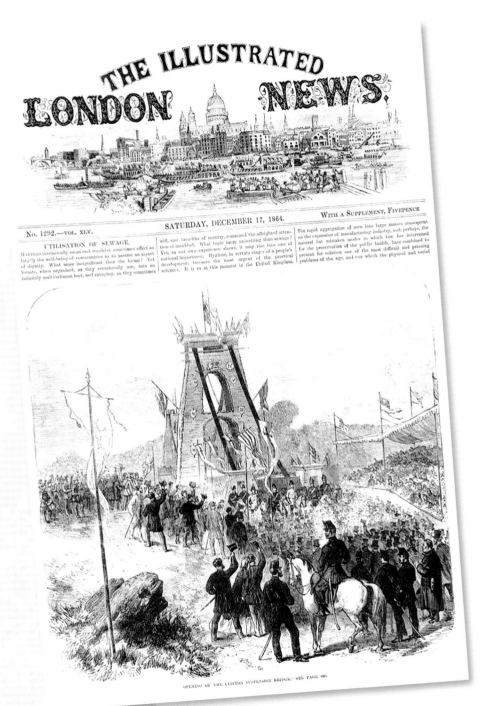

Caption for the Illustrated London News engraving (reproduced within the image): masthead reading "THE ILLUSTRATED LONDON NEWS", "No. 1292.—Vol. XLV.", "SATURDAY, DECEMBER 17, 1864.", "With a Supplement, Fivepence", article headed "UTILISATION OF SEWAGE", and lower caption "OPENING OF THE CLIFTON SUSPENSION BRIDGE.—SEE PAGE 600."

progressed to the stand. After speeches, the Lord Lieutenants of Gloucestershire and Somerset – the Earl of Ducie and the Earl of Cork respectively – declared the bridge open. The first across were the contractors, resident engineer Thomas Airey, and seventy workers. On their reaching the far side there was an artillery salute. They then returned to the Clifton side. The *Bristol Mercury* reported that the Bishop of Gloucester and Bristol seemed less assured than his colleagues of the strength of the bridge and in the prayers which followed petitioned the Lord to sustain 'in safety and permanence the highway'. Then followed the national anthem and another salute concluded the proceedings.

The dignitaries later adjourned to the Victoria Rooms where a banquet awaited them. The condition of the diners can only be imagined after thirty toasts and replies and several lengthy speeches were made.

VICTORIA ROOMS, CLIFTON.

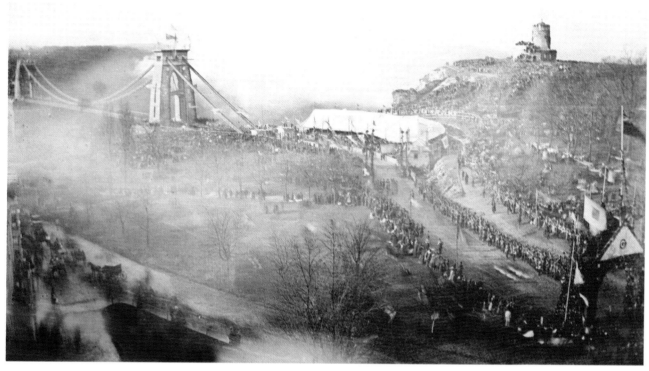

Opposite page:
Left: The only national magazine image of the opening ceremony was this engraving, which appeared in the Illustrated London News of 17 December 1864. The profusion of flags on the tower is very evident; Right: The Victoria Rooms, scene of the banquet after the opening, now house the University of Bristol's music department. The menu included sweetmeats in a pastry case, christened 'Clifton Puffs'. (Both Private Collection)

Left: Despite it being such a major event, this indistinct photograph of the opening ceremony is the only surviving one. The contractors and engineers are leading the procession across the bridge. (Clifton Suspension Bridge Trust)

In a radio broadcast in 1936, Mary Griffiths claimed that she was the first member of the public to cross the bridge: 'When the signal was given and the gate opened, I decided to be the first across.' While her uncle cheered her on, she raced and narrowly beat a young man – a splendid effort considering her long skirts! The 21-year-old must have been fit – she lived to the age of 94, much more unusual in the 1930s. (Clifton Suspension Bridge Trust)

In the evening there was to be a demonstration of the bridge lit by electricity, billed as 'the most interesting and novel event of the day'. Unfortunately it did not live up to the hype. A brisk wind – which caused boys to cheer 'at the contortions of females to keep their crinolines in subjection' – blew out the six magnesium flares at the base of the piers, and the electric lighting worked only intermittently. It was unanimously declared as disappointing, one spectator describing it as 'an insignificant twinkle'. The huge crowd leaving the site caused the greatest traffic jam that Bristol had yet experienced – one of many to follow!

Only one photograph, of poor quality, taken from the roof of the Bath Hotel and an engraving in the *Illustrated London News* record the day.

The bridge was not open to foot passengers until the following day and within three days 100,000 people had crossed. Vehicles were not allowed until 23 January the following year.

As the *Bristol Mercury* put it, 'The chasm has been spanned'. Finally, 110 years after Vick's donation, his wished-for bridge was completed.

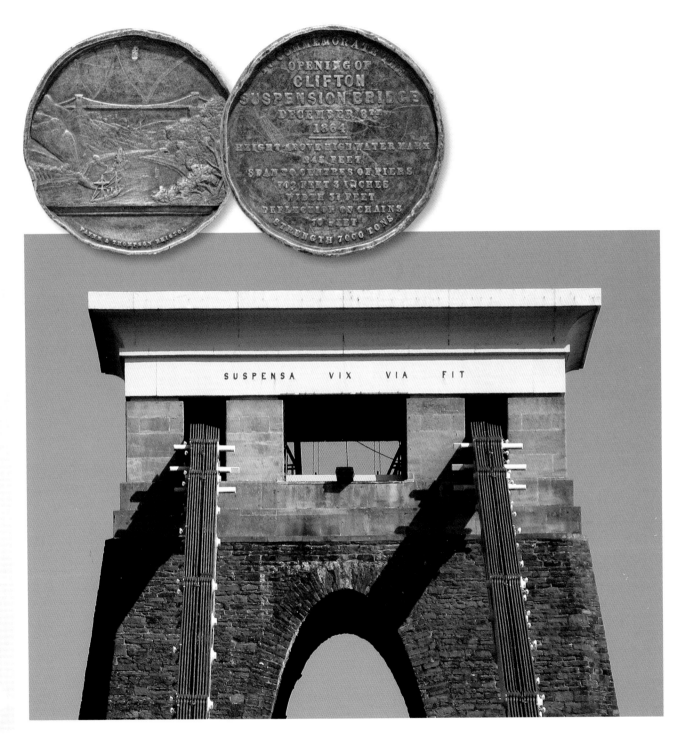

A batch of 1,200 medals in nickel was struck by the directors to mark the ceremony, and they were sold at £5.00 each. Local businesses also cashed in on the opening ceremony, offering celebratory dinners, engraved prints of the bridge and 100,000 commemorative medals of three sizes at one penny, fourpence and sixpence, while a Mr Austin Phillips advertised sheet music for 'The Clifton Suspension Bridge Quadrilles'. (Clifton Suspension Bridge Trust)

Victorians could rarely resist a pun. On the Leigh Woods abutment is the inscription 'Suspensa vix via fit'. This is adapted from the Latin writer Horace and means 'a suspended way built with difficulty'. The word 'vix' is probably a play on words with the name 'Vick'. (Private Collection)

17

THE BRIDGE SINCE 1864

What could have been an environmental disaster occurred even before the bridge was opened: in 1863 Sir Greville Smyth proposed to build 435 houses, a church and hotel on the Leigh Woods side of the gorge, including an iron bridge across the popular beauty spot 'Nightingale Valley'. A year later he sold his woods to a developer, who intended to build 800 houses but found he could not afford to pay Smyth. The Leigh Woods Land Company was formed to fight this. It bought the land from Smyth for £40,000, and development was by permission only. The land company retrieved their investment by selling sites, usually in fits and starts depending on the economy of the period. In 1909 the tobacco baron George Alfred Wills bought 80 acres and presented it to the National Trust. His brother Walter Alfred Wills gave another 60 acres in 1936, which included the quarries that were gradually eroding the landscape. In 1947 the Forestry Commission acquired a further 300 acres. Today the woods form a National Nature Reserve.

Soon after the bridge opened, trestle tables were set up, selling drinks and souvenirs to the increasing numbers of tourists. Much of the pottery was made in Germany before the First World War, but afterwards in Britain. The tables were replaced by a kiosk in 1866 at a rent of £50 per annum. In 1956 the contract with the proprietor of the third kiosk on the site specified that he was to 'refrain from selling ... indecent or vulgar photographs, picture postcards and such like', and so Donald McGill's saucy seaside postcards were no longer stocked. In the 1960s the rent was raised to £65, the first increase for a century. The kiosk was finally demolished in April 1970. The Avon Gorge has often attracted stunts. In 1736 a Thomas Kidman 'flew ... with fireworks and pistols; after which he went up on the rope, and performed several surprising dexterities on it'. His frequent 'flying' finally ran out when he was killed in Shrewsbury, but he is immortalised in by Hogarth in *Southwark Fair*, where he is shown flying from a steeple.

The well-stocked kiosk can be seen against the left-hand Clifton tower in this early twentieth-century photograph. (Bristol City Reference Library)

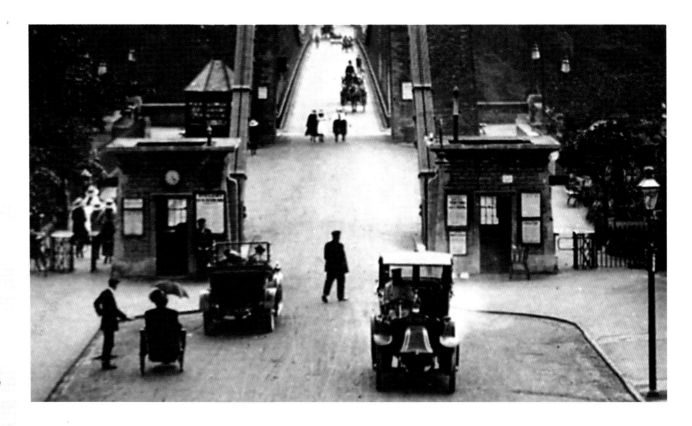

Many of the pottery souvenirs were made in Germany before the First World War. They were made in England afterwards, to a lower quality. The designs must have appealed to the tastes of the time! (Clifton Suspension Bridge Trust)

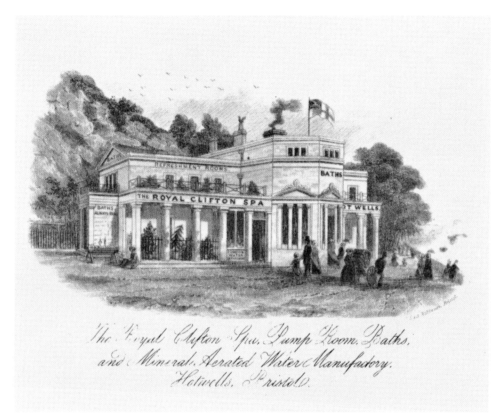

The Royal Clifton Spa, Pump Room, Baths, and Mineral Aerated Water Manufactory. Hotwells, Bristol.

The new Hotwell House continued as a spa, with ever-decreasing profits until the promontory on which it stood was demolished in 1867 to aid navigation. The water was piped to a cavern at the side of the road. It still exists but was eventually closed on health grounds in 1913. (Private Collection)

Bristolians ironically waiting for 'Larry' Donovan to jump from the bridge, as seen by the local comic paper The Bristol Magpie. *(Private Collection)*

In 1826 an American, Mr Courtney, glided over to the Leigh side, suspended horizontally from a rope with a flag in both hands to represent Icarus. Unfortunately, the men meant to catch him missed and he hit a tree and bruised his side. His courage was not well rewarded and he collected very little money, but a benefit concert was arranged for him at the Hotwell Spa.

In 1888 Lawrence M. Donovan claimed to have jumped from the Brooklyn Bridge in New York and alleged that he had also dived from the Clifton bridge, but because of the 'unbelief generally prevailing' said that he would repeat the stunt on Good Friday. After two more threatened attempts, each of which was foiled by the police, he was arrested and charged with attempted suicide. He gave an assurance that he would not repeat the attempt.

In 1896, a music hall entertainer, calling himself Zanetto the Japanese Juggler, caught a turnip thrown from the bridge on the point of a knife held in his mouth as he stood at the foot of the gorge. His act never varied much – in the 1920s at the Bristol Hippodrome he was catching oranges issued by the management on a fork.

Yet another music-hall performer, 30-year-old 'Professor' William Finney was set to dive off the bridge, but the police got wind of his intentions and prevented him. He was to make another attempt a few days later but as he arrived on the bridge, watched by 200 people, at about 5 a.m. (high tide being twenty minutes later), he was closely watched by three policemen and again prevented. Another attempt half an hour later was also foiled and he was arrested on a charge of attempting to commit suicide. In court he claimed to have dived from high bridges in Germany, Austria and Tower Bridge. Finney promised not to repeat his attempt and produced a surety of £10.

Despite his Italian stage name, Englishman Zanetto dressed in Japanese robes, following the interest at the time in all things Japanese. (Clifton Suspension Bridge Trust)

On April Fool's Day 1979 Britain's first bungee jump was made from the bridge by the Oxford University Dangerous Sports Society. Dressed in morning dress and top hats and carrying champagne bottles, four members jumped at the same moment, one admitted to hospital with rope burns. Actions like these are now illegal.

One of Bristolians' most treasured stories is that of Sarah Ann Henley. After quarrelling with her boyfriend, a railway porter, allegedly because of her sharp tongue and flirting, the 24-year-old barmaid jumped from the bridge. Most Bristolians believe that her crinoline enabled her to parachute gently down unharmed. Unfortunately, this didn't happen. Although her skirts certainly lessened the impact and carried her into a mud bank, she was still injured when dragged out by two passers-by. A doctor examined her and asked a nearby cabbie to take her to the Bristol Infirmary, but he refused to carry the muddy creature in his newly-cleaned cab – even if he was paid £10. She was therefore carried by hand to the infirmary on a stretcher, which took over an hour. Somehow Sarah survived. She eventually married another man and died at the ripe old age of 84.

Sarah Ann Henley who survived plunging from the bridge and gave rise to one of Bristol's enduring myths. (Clifton Suspension Bridge Trust)

By 1865, gas lighting had been installed on the bridge. It was replaced by electricity in 1928. For many years the bridge was illuminated only on special occasions such as coronations (6,000 bulbs alone in 1953) and jubilees, and for a week at Christmas and Easter. It was also lit to mark the centenary of Brunel's death in 1959 and the bridge's centenary in 1964. From 1982 the bridge began to be lit from dusk until 1 a.m. during the summer months, using almost 4,000 25W bulbs. These were often vandalised, especially by those celebrating the end of exams. One man marking the acceptance of his marriage proposal was fined £25 for stealing a bulb to give to his fiancée as a souvenir. The system of bulbs meant a great deal of work for the staff as well as consuming a huge amount of electricity. A new system was installed in 1992 but was unsatisfactory

The original use of bulbs has been replaced by dimmable LED lighting which shows off the structure of the bridge. Uplighting also shows off the stonework of the towers and light is projected to show the abutments and cliffs. (Clifton Suspension Bridge Trust)

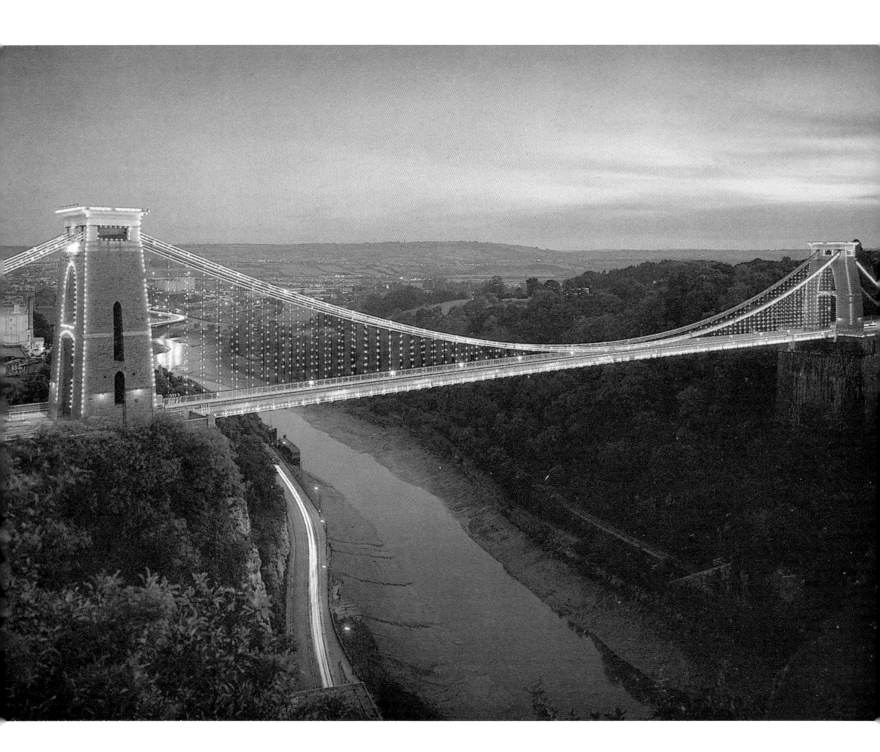

and replaced by the present LED system, which outlines the structure of the bridge and is much 'greener'. No longer can maintenance staff be seen walking the chains, without harness, with a bucket of bulbs over their arm.

At midnight on a cold and rainy night on 18 September 1896, Charles Brown, a grocer from Birmingham who was facing bankruptcy, threw his daughters, Ruby, aged 12, and Elsie, 3, from the bridge. It is possible that he intended to commit suicide as well. Fortunately, it was high tide and there was a pilot boat almost immediately below which rescued the two girls. Ruby had damaged her spine and Elsie had leg injuries. The pilot, Jacob Hazell, got them ashore. Two policemen arrived and carried them to hospitals where they both later recovered. Charles Brown was arrested and brought to trial but was found to be insane and sent to an asylum.

Sir Alan Cobham, who ran a very successful 'Flying Circus', claimed to be the first person to fly under the bridge as early as 1912. In 1916, Lt Basil Scott-Foxwell of the Royal Flying Corps took a bet for £5 from his instructor to fly under the bridge, which he accomplished on Christmas Day, his instructor circling above to check that he had done it. Later this was to become almost a rite of passage for young pilots. During the 1930s, and especially the Second World War, pilots again began the exploit. Fifty years after he had flown under the bridge Group Captain Peter Heath confessed that as a young Pilot Officer in 1930 he had performed the feat in an Armstrong Whitworth Siskin fighter in response to his friend's words, 'That bridge needs flying under.' He had kept quiet for half a century because he could have been fined £200 and his pay was just 15s a day! However, these stunts sometimes ended in tragedy. In 1957, 501 Squadron R Aux AF was being

M. Tetard in Flight Over Clifton Suspension Bridge. No. 6.

Above: The first person to fly over the bridge was the Frenchman Monsieur Tetard in 1910, just a year after Bleriot's pioneering flight across the English Channel. (Clifton Suspension Bridge Trust)

Right: The original toll house in the Edwardian era. It was later demolished. (Private Collection)

Opposite: In 1975, when this photograph was taken, tolls were collected manually, with the collector standing in the exhaust fumes. As the number of vehicles using the bridge increased, automatic barriers were brought in. (Clifton Suspension Bridge Trust)

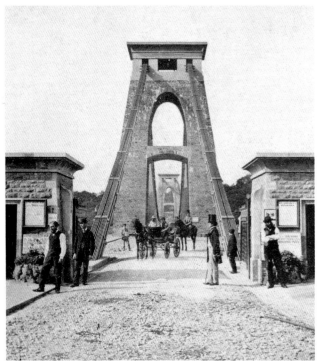

disbanded. A young pilot from the unit decided to mark the sad occasion by flying under the bridge at 450mph in his Vampire jet. He cleared the bridge but caught the Leigh side of the gorge, crashed and was killed. Since then the feat has not been performed and it is illegal to fly over or under the bridge.

During the Second World War the bridge was a useful reference point for enemy bombers and in December 1940 a stick of bombs slightly damaged the Leigh Woods toll houses. Five months later, four incendiary bombs fell on the bridge but were quickly extinguished.

By 1949 the bridge trustees had finally acquired all the debentures in the company formed in 1861 and obtained a new Clifton Suspension Bridge Act of 1952. On 1 January 1953 the company was liquidated. Under the new Act there are ten trustees who are selected for their technical or professional knowledge, plus one councillor each from Bristol City Council and North Somerset County Council. The Act charges the trustees to make investment to maintain an emergency repair fund. Day to day running is carried out by the bridgemaster (who is a qualified engineer), thirteen toll attendants, three maintenance men and three office staff.

In 1958 the original toll houses on the Clifton side were demolished and replaced with more modern facilities. Toll attendants are on duty twenty-four hours a day and also play an important role in ensuring the safety of the public and preventing damage to the bridge. The barriers, introduced in 1975, allow only fifteen vehicles at a time on to the bridge and on the approach roads metal weight watchers

Today 4 million vehicles pass through the automatic barriers each year. The bridge can now be viewed from the toll houses by CCTV. (Clifton Suspension Bridge Trust)

In 1994 a lookout point from which to view the bridge was established on Sion Hill, Clifton by the Clifton and Hotwells Improvement Society and the bridge trustees. A lectern gives the bridge's statistics. (Private Collection)

ensure the maximum weight of 4 tons is not exceeded. A speed limit of 25mph on the bridge is also imposed.

In the 1970s, plans were announced for the extension of the Grand Spa Hotel (now the Avon Gorge Hotel) down the side of the gorge, just 150 yards from the bridge. After a public enquiry, in which Sir John Betjeman gave evidence for the opposition, the plan was rejected, costing the City Council, who had agreed to the development, a large sum in compensation.

In 1975 and 1976, a competition was run for '20 Ideas for Bristol'. This produced both serious and amusing suggestions, Bristolians particularly liking the idea of a model of Brunel doffing his stovepipe hat as each motorist paid to pass through the barriers.

It is a melancholy fact that the bridge has attracted suicides since the first case, eighteen months after the bridge opened. Since the 1990s the trustees have made strenuous efforts to stop such attempts. This has posed both problems of potential wind resistance, which could compromise the safety of the bridge, as well as aesthetic problems for a Grade I listed

structure. The current wire barriers along the parapet have proved very successful as a preventative measure, while not detracting from the appearance of the bridge.

The survival of the bridge has been due to the high level of maintenance it has received. Each year the consultant engineers carry out a thorough inspection and indicate actions required, including repair, replacement components, cleaning or repainting. In the course of its life the bridge has seen its upper layers of deck timber replaced, the anchorages strengthened, new cradles provided for work below the deck, repairs to bolts and suspension rods, cleaning of the abutments, coating of the cross girders with zinc and, of course, regular painting of the ironwork. In 2005 access equipment was installed in the towers. The three-strong maintenance team also repair the coin collecting

On the 100th anniversary of Brunel's death, 15 September 1959, a green slate plaque with an inscription and a relief portrait of Brunel was placed near the Clifton toll gate. It was unveiled by the Dowager Lady Noble, Brunel's granddaughter. (Clifton Suspension Bridge Trust)

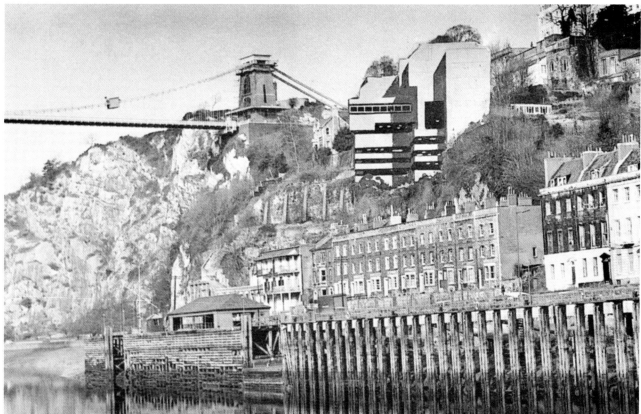

The threat of a 126-bed hotel and multi-storey car park down the side of the gorge, planned by the Grand Spa Hotel, was only averted by strong public opposition. (Private Collection)

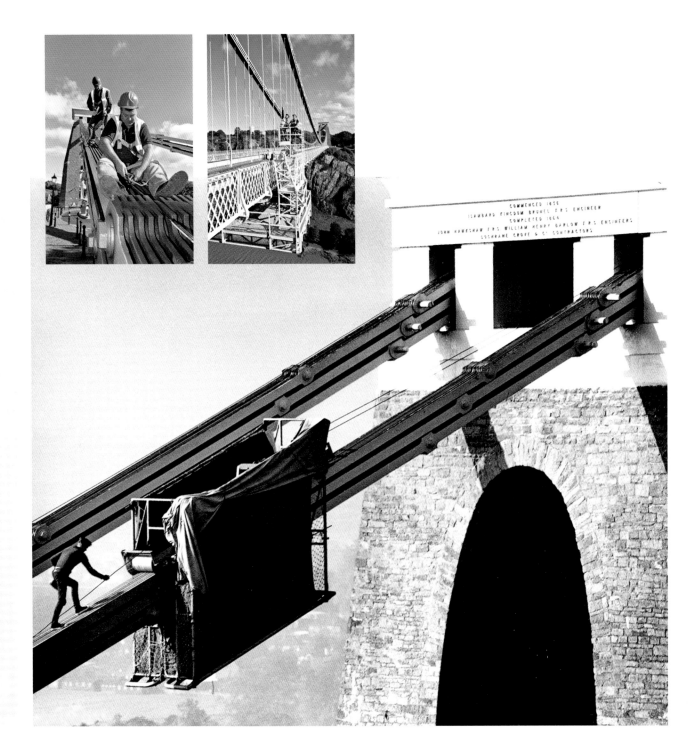

The concern for health and safety has changed considerably since the first photograph was taken in the 1950s. Today the maintenance crew buckle on their safety harness before climbing the chains. (Clifton Suspension Bridge Trust)

machines and the barriers if they break down. The permanent bridgemaster is assisted by a subcommittee of trustees with engineering experience. Before the era of health and safety, the men were not equipped with ropes or safety harness. Today the maintenance workers are much better protected.

Recently, an improved drainage system has stopped rainwater corrosion of the cross girders under the deck. Current maintenance plans include extensive conservation of the 170-year-old masonry – a major operation – and overall maintenance will require over £10 million during the next ten years. Meanwhile, running costs of the bridge are £1 million a year. The replacement of some of the suspension rods and bolts after meticulous state-of-the-art investigation reflects the very high level of care provided by the trust. A new paint system also forms part of a twenty-year strategic plan, as does a geotechnical survey of the rock strata to ensure stability.

Planning permission has recently been obtained to modernise the maintenance and administrative accommodation and for the creation of a new heritage centre on the site of the current maintenance yard on the Leigh side.

The story of the achievement of the building of the bridge is a long, drawn-out and complex one, dogged as the process was for much of the time by insufficient funds and poor financial administration, civil unrest, economic booms and slumps and alternative investment opportunities. Over a century passed from the making of William Vick's legacy to the bridge's completion. Hawkshaw and Barlow finally completed the bridge, on time and on budget. While they modified Brunel's design, they also respected his concept, and in December 2014 the bridge and its many admirers will celebrate the 150th anniversary of this superb structure.

Brunel favoured a stovepipe hat, probably to enhance his moderate height. (Private Collection)

Plans for the new visitor centre, which will be positioned within a few yards of the Leigh entrance. It will be opened to coincide with the 150th anniversary of the opening of the bridge. (AlecFrenchArchitects)

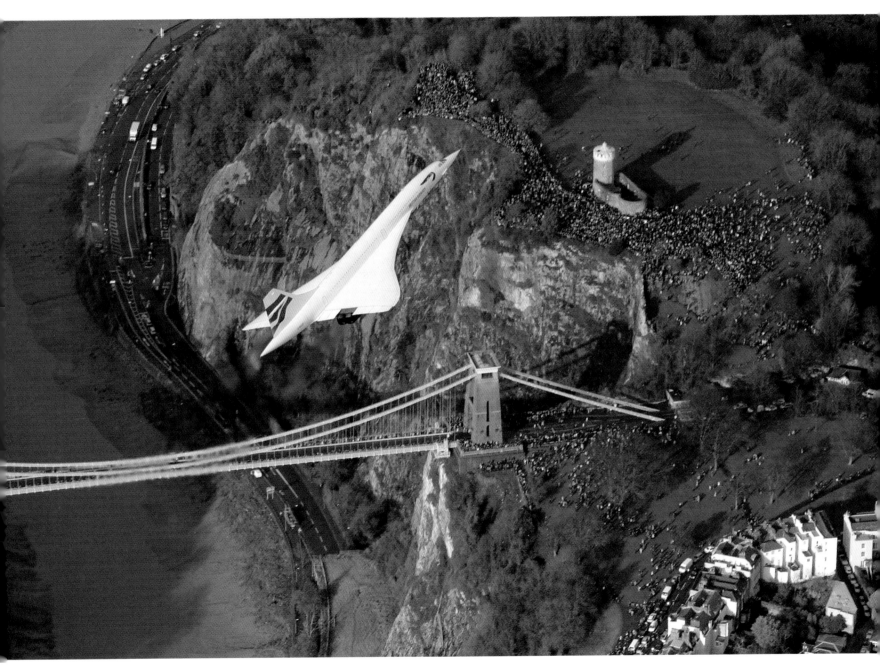

In 2003 the Concorde aircraft, built in Bristol, appropriately made its farewell flight over the bridge. Thus one symbol of twentieth-century technology paid its respects to perhaps the ultimate symbol of nineteenth-century technology. (swn.com)

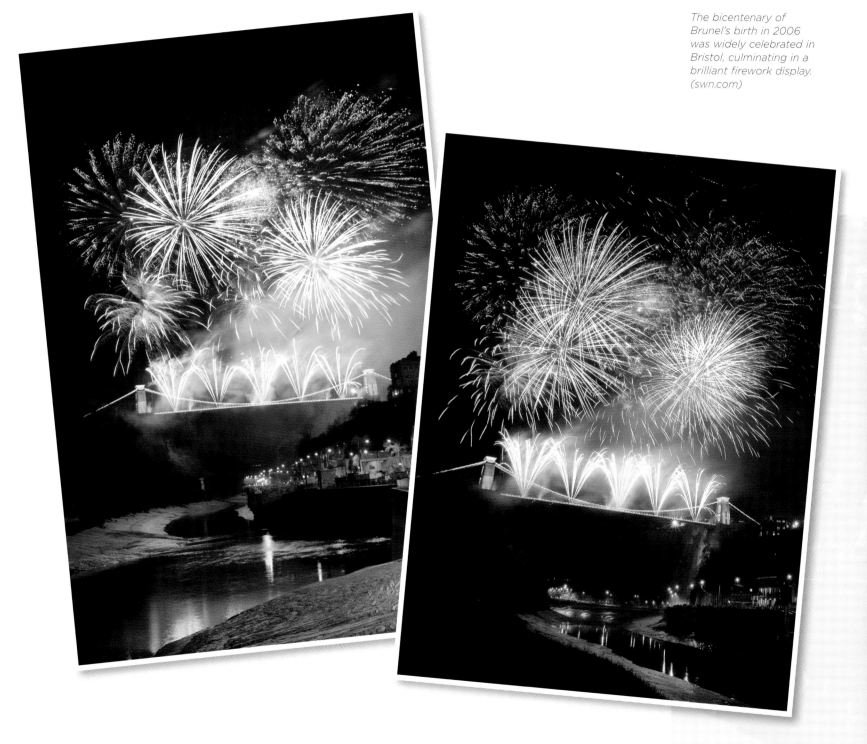

The bicentenary of Brunel's birth in 2006 was widely celebrated in Bristol, culminating in a brilliant firework display. (swn.com)

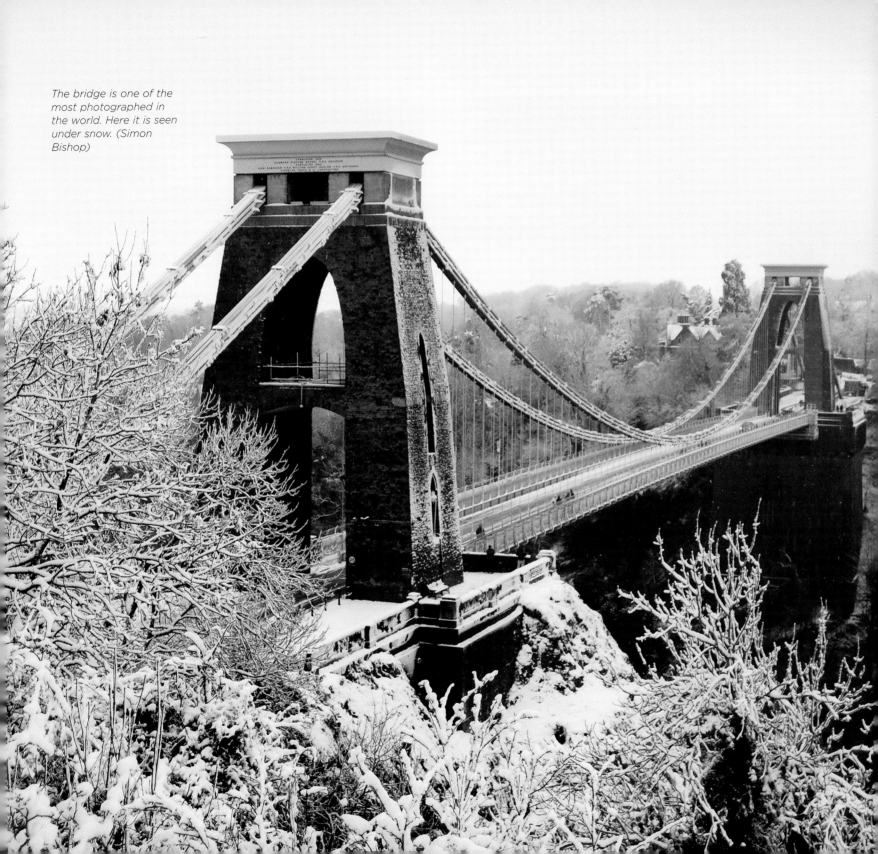

The bridge is one of the most photographed in the world. Here it is seen under snow. (Simon Bishop)

Appendix 1

FACTS AND FIGURES

Distance between the towers: 702ft
Height of towers: 86ft
Distance between the anchorage pits: 1,352ft
Road width: 31ft
Height above high tide: 245ft
Chains anchored 70ft in the rocks
500,000cu. ft of masonry in the Leigh abutment, which is 110ft high
Total Weights: Towers 4,000 tons (estimate); Chains 2,100 tons; Road deck 1,500 tons
Total building cost: £100,000
The bridge has 4,200 links, each weighing ½ ton and 2ft in length, 400 connecting pins,
 162 suspension rods and 81 cross girders.
The suspension rods vary in height from the tallest at 65ft to the shortest at 3ft.
The main chains are 20in longer on a warm day than on a cold one, due to expansion.
4 million cars and ½ million pedestrians cross the bridge every year.
The road level on the Somerset side is 3ft lower than the Clifton side. It is believed that Brunel
 realised that the profile of the rock would have made a level bridge appear uneven and
 designed the difference to counteract this

There are three differences one side from the other:
1. The Leigh tower has no lancet openings in its side unlike the Clifton tower.
2. The Leigh tower has a chamfered edge, the Clifton tower is square edged.
3. The inner arch of the tower on the Clifton side is semi-circular, that on the Leigh side more
 pointed. No one knows quite why.

Appendix 2

BRUNEL THE MAN

Isambard Kingdom Brunel was responsible for designing over twenty railways in Britain, Italy and India as well as bridge and viaduct building, waterworks, docks and marsh draining. His reputation as one of the greatest British engineers is today assured. We now celebrate his achievements: his Great Western Railway, his bridges and his ships – all of which were far in advance of their time.

Yet it was not always the case. Many of Brunel's projects were much over budget – not uncommon in civil engineering – or complete failures, and his investors lost heavily, as he himself did with the *Great Eastern*. In 1887 the Bristolian journalist, John Latimer, possibly one of these disappointed investors and a Northumbrian by origin, wrote that the Great Western Railway board had committed 'a deplorable error' in neglecting 'the sober-minded, practical and economic engineers of the North, already deservedly famous'. In fairness to Brunel, he had warned the GWR directors in advance that they would not obtain the cheapest railway, but certainly the best. Few could deny that his smooth route over much of the terrain between Bristol and London, nicknamed 'Brunel's billiard table' and his 7ft gauge made for a comfortable and safer journey.

Much of his work was not so much inventive as imaginative and daring expansions and improvements to what previously existed. It has been argued that his father Sir Marc Brunel, more unassuming in character, was the greater innovative engineer, and there is no doubt that Brunel learnt much from his father, who helped him greatly in his early career. Yet, unlike his father, Brunel knew the value of publicity, which, combined with charm and technical and artistic ability, was capable of swaying both boardroom directors and MPs.

Few men are without contrasts in character. The 'Little Giant', as he was known, was dedicated but a workaholic and reluctant to delegate. He has been accused of being authoritarian, not appearing to care for the health and safety of his workforce – not an uncommon Victorian

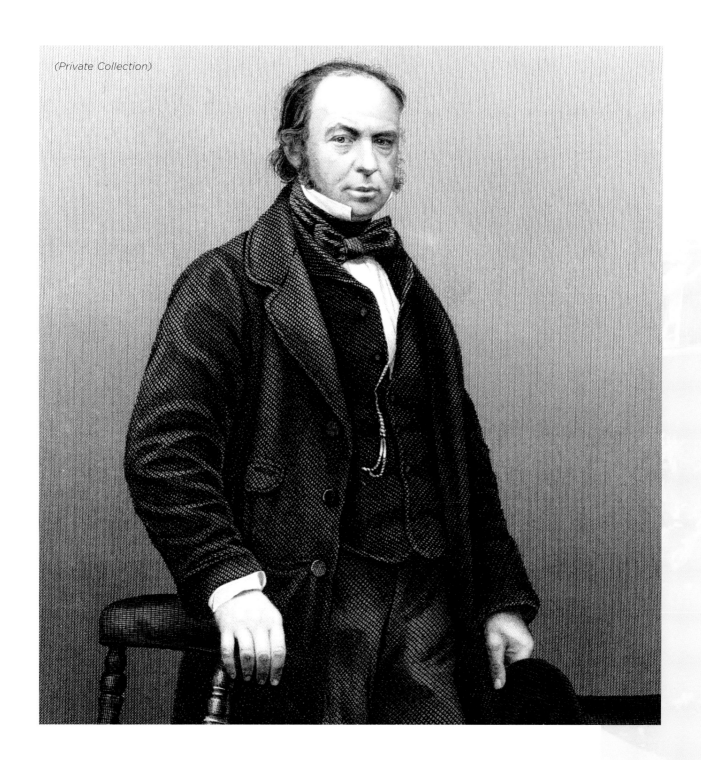

characteristic. Yet even from a young age his workers looked to him as their leader. He also undoubtedly showed personal courage on several occasions.

He was not unaware of his own faults. At the age of 21, when still seeking work, he admitted in his diary 'As to my character – my self-conceit and love of glory vie with each other which shall govern me. My self-conceit renders me domineering, intolerant and even quarrelsome with those who do not flatter.' Yet in a following entry he reveals a strong gift for self-mockery: 'I'll turn misanthrope. get a huge meerschaum as big as myself and smoke away melancholy – and yet that can't be without working for it.'

Some of Brunel's biographers have been charged with over-glorifying him while others have been accused of being hypercritical. Whatever Brunel's strengths and weaknesses of character his legacy lives on. The esteem in which he was held amongst his peers and the thousands of his contemporary citizens who attended his funeral testify to their regard. Probably one of the most impartial judgements was made following Brunel's death by his colleague Daniel Gooch, in his diary:

The commercial world thought him extravagant, but although he was so, great things are not done by those who sit down and count the cost of every thought and act.

It required his fellow engineers to complete his first major project. Now, 200 years later, it stands as a magnificent riposte to those who 'count the cost of every thought and act' but cannot achieve 'great things'.

The bronze maquettes (or models for the statues) were designed by British sculptor John Doubleday in 1982. It is apt that one statue of Brunel is in London and the other in Bristol, the two original termini of the Great Western Railway. (Clifton Suspension Bridge Trust)

Appendix 3

BRUNEL TIMELINE

1806	9 April: Isambard Kingdom Brunel is born at Portsea, Portsmouth, Hampshire, the son of Marc (later Sir Marc) Brunel and his wife Sophia, née Kingdom.
1820	Studies at Caen College, then at the Lycée Henri IV in Paris.
1822	Completes period with watchmaker Louis Bréguet. Returns to England to assist his father.
1825	Work begins on the Thames tunnel under Marc Brunel, the first ever tunnel under a river.
1827	Brunel appointed resident engineer to the tunnel. The tunnel floods but is repaired.
1828	The tunnel again floods and Brunel is injured, narrowly escaping with his life. Sent to recuperate in Brighton and then London. (There is no evidence that Brunel came to Bristol in 1828.)
1829	Enters four designs for a suspension bridge across the River Avon. No design accepted.
1830	Elected Fellow of the Royal Society, one of the youngest ever.
1831	Design accepted. Appointed chief engineer in March. Ceremony marking turning of first turf takes place in June. Work stops after the Bristol Riots in October.
1832	Works for the Bristol Dock Company.
1833	Appointed engineer to the Great Western Railway and surveys the route.

1835	Appointed engineer for the paddle ship *Great Western*, built in Bristol.
1836	Marries Mary Horsley. Foundation stone of Clifton bridge laid.
1837	*Great Western* launched in Bristol.
1838	Brunel injured after fire in the engine room of the *Great Western*.
1841	London–Bristol Great Western Railway and Bristol Temple Meads station completed.
1843	Launch of SS *Great Britain,* the world's first screw-driven, iron-built ocean liner, not surpassed for almost forty years.
1844-45	Brunel appointed engineer to several railways.
1845	Hungerford suspension footbridge, London, designed by Brunel, opens.
1849	New lock at Cumberland Basin, Bristol, opens.
1850	Joins the building committee for the Great Exhibition of the following year.
1854	London Paddington station opens.
1855	Designs prefabricated hospital to send to the Crimea, where sickness during the war costs more lives than wounds.
1858	*Great Eastern* launched in London.
1859	Royal Albert Bridge, linking Devon and Cornwall, completed. Brunel suffers a stroke and dies on 15 September, aged 53.

Appendix 4

BRIDGE TIMELINE

1754	William Vick bequeaths money towards building a toll-free stone bridge.
1793	William Bridges' proposal for a massive stone bridge.
1826	Thomas Telford's Menai Bridge attracts great attention.
1829	Committee formed and first competition announced. Twenty-two entries. Brunel submits four designs. The judge, Thomas Telford, rejects all entries. Committee invite Telford to submit plans.
1830	Telford submits his own design (January). After popular disapproval a new competition is announced (October). Twelve entries, five shortlisted.
1831	One of Brunel's designs accepted. He is appointed Chief Engineer (March). Small ceremony. Slow collection of subscriptions. Bristol Riots (October) bring work to a halt.
1835	Work resumes on Leigh Woods abutment.
1836–37	Financial disputes between contractors. Cheaper schemes suggested by others.
1840	Leigh Woods abutment completed but absorbs much of the available funds. Ironwork ordered.
1843	Both towers completed. Insufficient funds to continue and work stops.
1845	Brunel's Hungerford suspension footbridge opens.
1851	Clifton ironwork sold and used on Brunel's Royal Albert Bridge, Plymouth.
1853	Crossing bar removed.

1859	Death of Brunel.
1860	Engineers Hawkshaw and Barlow suggest using ironwork from Hungerford Bridge to complete the Clifton bridge as a memorial to Brunel. New company formed, funds raised and Act of Parliament passed.
1863	Construction begins. Changes made include longitudinal girders, widened roadway and an additional chain on each side. Decorative panels and sphinxes omitted to save costs.
1864	Chains completed, roadway suspended, toll houses and approach roads built. Tested successfully by the Board of Trade. Opening ceremony 8 December.
1865	Fully opened to (horse) traffic.

Appendix 5

CLIFTON SUSPENSION BRIDGE ACT 1830

The following List of Tolls to be taken:

For every horse or beast drawing any coach, barouche, sociable, berlin, chariot landau, chaise, caliche, chair, phaeton, caravan, cart with springs, hearse, litter, of such like carriage (except stage coaches) a sum not exceeding the sum of 6*d*.

For every horse or beast drawing any stage-coach licensed to carry in the whole, inside and outside, not more than nine passengers, a sum not exceeding the sum of 6*d*.

For every horse or beast drawing any stage-coach licensed to carry in the whole, inside and outside, more than nine passengers, and not exceeding sixteen passengers, a sum not exceeding the sum of 7½*d*.

For every horse or beast drawing any stage-coach licensed to carry in the whole, inside and outside, more than sixteen passengers, a sum not exceeding 9*d*.

For every horse or beast drawing any caravan, tilted wagon, tilted cart, or other such carriage, carrying passengers for hire, licensed or unlicensed, a sum not exceeding the sum of 6*d*.

For every horse or beast drawing any wain, waggon, or cart, or other such carriage, drawn by not more than two horsed or other beasts, a sum not exceeding the sum of 4½*d*; and drawn by three of four horses or other beasts, a sum not exceeding the sum of 6*d*; and drawn by a greater number than four horses or other beasts, a sum not exceeding the sum of 9*d*.

For every horse, mule, or ass, laden or unladen, and not drawing nor carrying more than one person, a sum not exceeding the sum of 2*d*; and if carrying more than one person, then a further sum not exceeding the sum of 1*d* for every additional person.

For every drove of oxen or other neat cattle, a sum not exceeding the sum of 6*d* per score, and so in proportion for any less number.

For every drove of calves, swine, hogs, sheep, or lambs, a sum not exceeding the sum of 3*d* per score, and so in proportion for any less number.

For every foot-passenger, or person on foot, for each time he or she shall pass or re-pass on or over the said bridge, Roads, or Approaches, (except the person or persons not exceeding two in number, actually driving and accompanying any waggon, wain, cart, or other such like carriage, the sum of 1*d*.

For every carriage with four or more wheels, not drawn by any horse or other beast, but propelled or moved by machinery, a sum not exceeding the sum of 2*s*; and for every carriage with three or less number of wheels, not drawn by any horse or other beasts, but propelled or moved by machinery, a sum not exceeding the sum of 1*s*.

Horses and Carriages not to pass and re-pass a second time in the same day until a fresh toll be paid. Stage-Coaches to pay each time of passing. Weight to be carried over the bridge to be limited hereafter. Power to borrow money and to mortgage the Tolls, Promissory Notes may be given for the security of money due on the credit of the Tolls, at an interest not exceeding five per cent per annum.

(Extract from an article in the *Bristol Mercury*, 9 March 1830)

In the 1952 Act, fees were still included for 'every four or less number of oxen, cows, bulls or head of neat cattle less than twenty 1*s* 0*d*'. Pigs, goats, sheep and lambs were also included in the list of tolls.

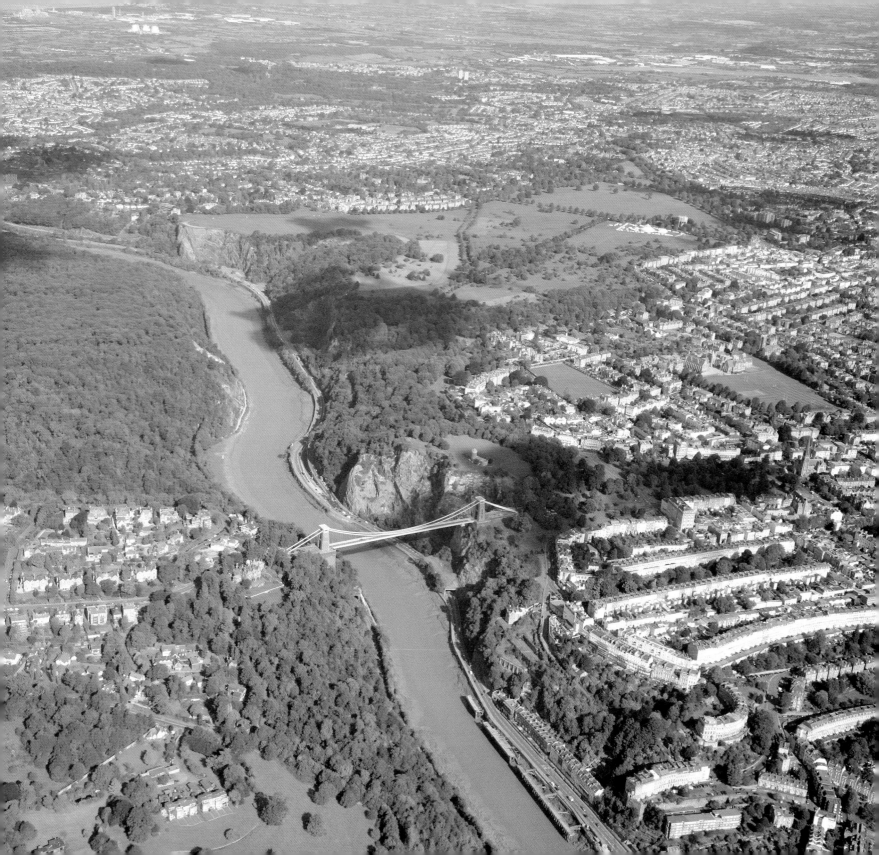

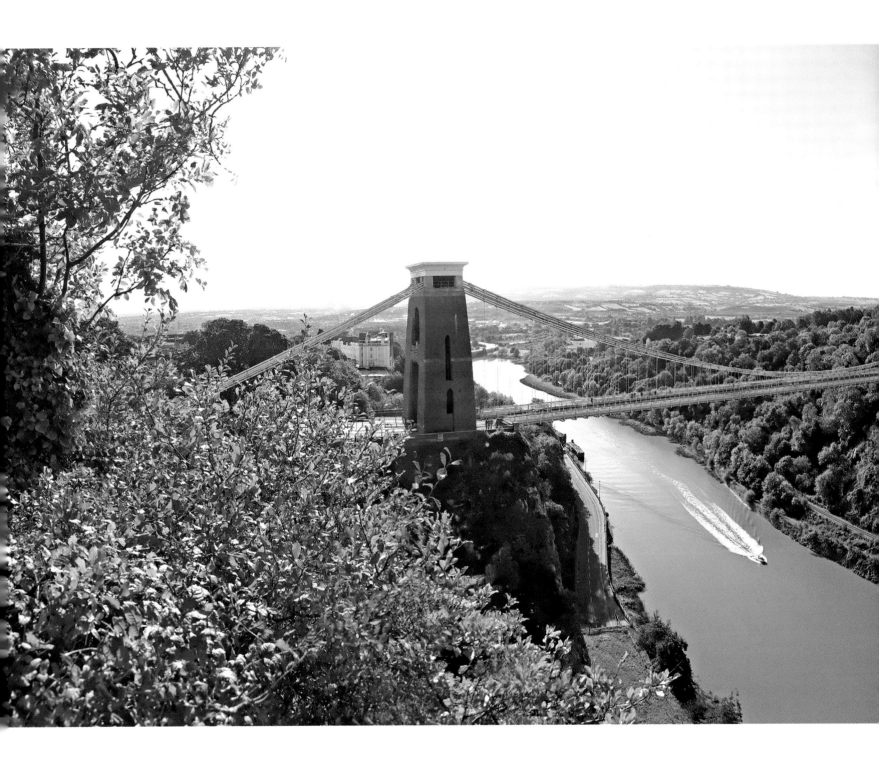

Brunel: pocket GIANTS

EUGENE BYRNE

In a BBC poll in 2002, Isambard Kingdom Brunel was voted the second-greatest Briton of all time, only eclipsed by Churchill. It's often claimed that that through his ships, bridges, tunnels and railways Brunel played a critical role in creating the modern world. In the soaring ambitions of the Victorian age, nobody thought bigger than Brunel. Never tied to a dusty office, he crammed enough work, adventure and danger into a single year to last a lesser person a lifetime. He was also a brilliant showman, a flamboyant personality and charmer who time and again succeeded in convincing investors to finance schemes which seemed impossible. Brunel made plenty of mistakes, some of them ruinously expensive. But he also designed and built several structures which are still with us to this day. For these we have to thank a man who was famously described as 'in love with the impossible'. -

978 0 7524 9766 2

The A-Z of Curious Bristol

MAURICE FELLS

Bristol's history is packed with peculiar customs and curious characters. This book explains why the vicar in one church goes on an annual trek to peer down a manhole; why captains of industry sing an eighteen-verse song in memory of Queen Elizabeth I; and how the Flower of Bristol got its name. You will meet some unusual contraptions, like the bed with in-built exercise equipment, or the thrashing machine for naughty boys. You will also discover why a public clock still runs to Bristol time. This compendium of the weird and wonderful will surprise even those Bristolians who thought they really knew their city. -

978 0 7509 5605 5

Visit our website and discover thousands of other History Press books.

www.thehistorypress.co.uk